HOW TO DRAW
CARTOON
DOGS, PUPPIES
& WOLVES

CHRISTOPHER HART

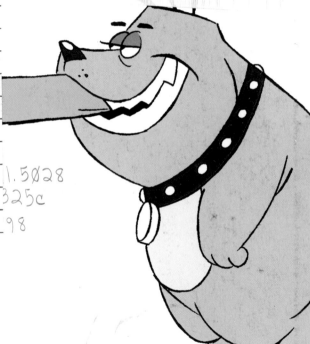

SHALL TRY IT

1.5028
325c
98

WATSON-GUPTILL PUBLICATIONS/NEW YORK

For anyone who loves to draw

Senior Editor: Candace Raney
Project Editor: Alisa Palazzo
Designer: Bob Fillie, Graphiti Graphics
Production Manager: Ellen Greene

Front and back cover art by Christopher Hart
Text and illustrations copyright © 1998 Christopher Hart

First published in 1998 by Watson-Guptill Publications,
a division of BPI Communications, Inc.,
1515 Broadway, New York, N.Y. 10036

Library of Congress Cataloging-in-Publication Data
Hart, Christopher.
 How to draw cartoon dogs, puppies, and wolves / Christopher Hart.
 p. cm.
 Includes index.
 ISBN 0-8230-2366-4 (pbk.)
 1. Cartooning—Technique. 2. Dogs—Caricatures and cartoons.
 3. Puppies—Caricatures and cartoons. 4. Wolves—Caricatures and
 cartoons. I. Title.
 NC1764.8.D64H37 1998
 741.5'8—dc21 98-16176
 CIP

Printed in Singapore

First printing, 1998

1 2 3 4 5 6 7 8 / 05 04 03 02 01 00 99 98

CONTENTS

INTRODUCTION

Dogs, puppies, and wolves are immensely popular in comic strips and animation. The cartoonist who can draw convincing dogs, puppies, and wolves has a leg up on the competition.

This book covers the most popular breeds of cartoon dogs, as well as a variety of mutts, wolves, and wacky characters. You'll have fun drawing your favorite dog breeds in the classic poses provided here. You'll learn how to draw action poses, a variety of expressions, and ultimately, how to invent your own characters. I also demonstrate how dogs walk and run, with a technique that helps you easily remember the correct succession of foot placements—a "must have" for anyone interested in animation. And even if you aren't interested in animation, per se, how are you going to draw a dog (or puppy, or wolf) in a walking or running pose unless you know where the feet go? You could spend hours making a beautiful drawing, but if it's physically impossible for the animal to walk that way, you'll have wasted your time.

I began my career in a small animation studio in Southern California, but before I could even sharpen my pencil, the producer asked me to design a dog character for an animated television commercial. Luckily, I had a couple of mutts of my own but no real knowledge of animal anatomy. So I did what any other beginning animator would have done—I designed a sheepdog so covered in hair that no one could tell if I had

the underlying structure right or not. It looked pretty good, the commercial got shot, and I got away with it.

But, you can't fake it forever. If the producer had asked me to draw a Doberman pinscher, I would have been in trouble. I would have had to make him cartoony and round in order to avoid drawing any anatomy. However, unlike a sheepdog, a Doberman *must* be drawn with sharp angles. If it's round, it loses its ferocity. When you fake a drawing, you stifle your creativity; you spend your time figuring out how to make things like the bend in the dog's leg look convincing, while people who know anatomy spend that time giving *personality* to their creations.

You've probably glanced at dogs a thousand times, yet you may not be able to correctly answer a simple question, such as, Where is its elbow? In fact, when I point out to people where the heel is on a dog, they're amazed. After working through this book, you'll have the practical knowledge that will enable you to develop a mastery of drawing dogs, puppies, and wolves.

Just a word of advice before you begin: Please don't trace. You'll learn so much more if you draw freehand, and you'll *retain* more. When you trace, the learning stops the moment you remove the underlying drawing. Take off the training wheels. I'll still be here to help you, but you will be the one doing it, and won't that feel good? So sharpen that pencil, get out some paper, and let's get started!

DOG BASICS

Perhaps the most popular pet in the world, the dog is also a favorite subject of animators and comic strip artists. If you want to be a cartoonist or animator, you have to know how to draw dogs convincingly, and this requires a basic understanding of a dog's anatomy and characteristics. In addition to getting the body right, you'll also need to master the ability to create a variety of facial expressions so that your cartoon dogs can communicate with your audience.

Drawing the Head

For all their differences, all dogs, regardless of breed, share the same basic head and body construction. By practicing these basic steps, you'll soon be able to draw any dog with impressive skill. Let's start with a breed that has a typical head shape and build—the ever-popular dalmatian.

1. Begin with a circle. It can be sloppy; it really doesn't matter. Drawing the guidelines on the circle will help you visualize it as a three-dimensional globe. The horizontal line hangs low on the globe—that's where the eyes will go. The vertical line is the *center line*—it divides the face in half.

2. The head has three basic components: the skull, the cheeks (which are exaggerated in cartoons), and the jaw.

3. Place the eyes on the horizontal "eye line."

4. The bridge of the nose begins high on the face—between the dog's eyes—and thrusts forward. Notice how it gets larger as it comes toward you.

5. Now add a smiling mouth, which pushes up into the cheeks and causes creases. The jaw, off to one side, creates a lively smile.

6. Big, floppy ears and a thick neck bring this guy to life. A few small teeth on the lower jaw add a professional touch.

7. Add spots, and erase your guidelines for a clean finished drawing.

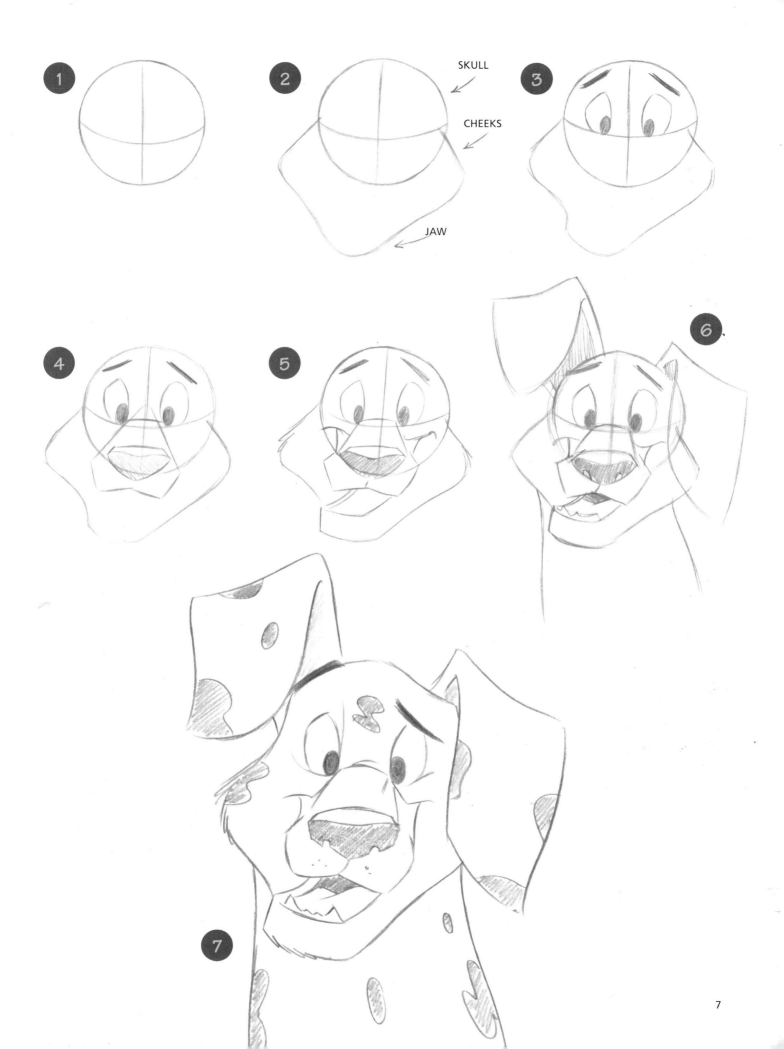

SKULL

CHEEKS

JAW

Turning the Head

These are the most popular, basic angles of the cartoon dog's head. If you start to have difficulty, go back to the construction stage. Spend at least as much time on that as you do on the finished version.

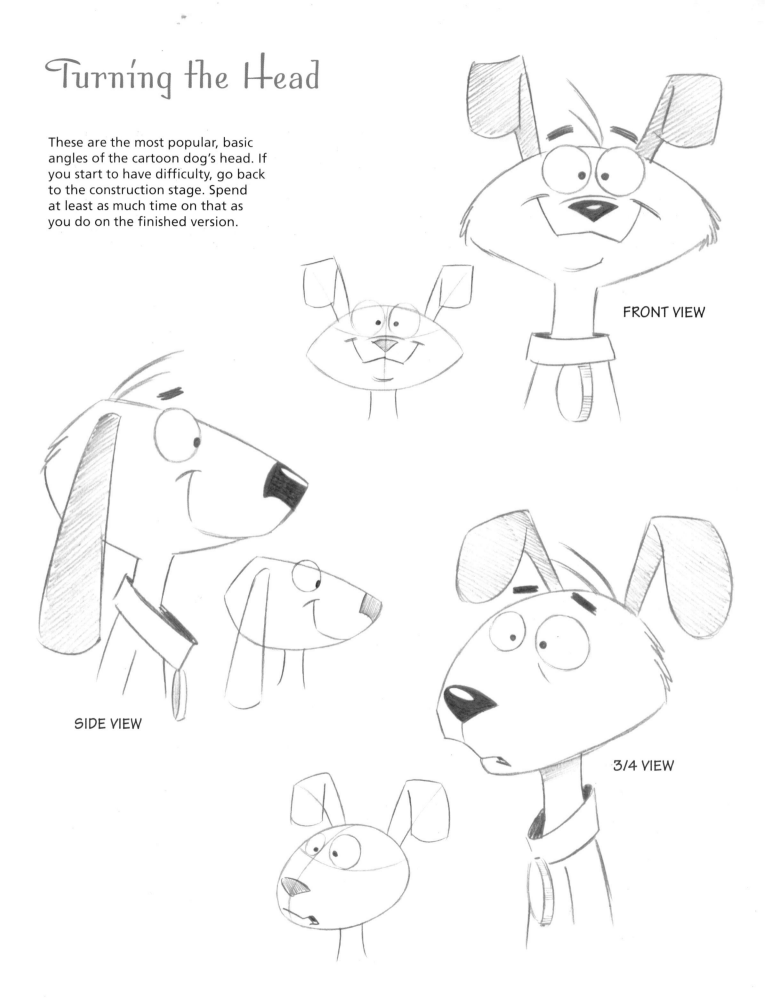

FRONT VIEW

SIDE VIEW

3/4 VIEW

Creating Expressions

Most people only think to use the mouth and the eyebrows to create facial expressions, but there's more to it than that. The shape of the eyes themselves changes, depending on whether the eyebrows crush down on the eyes or lift them up.

Most importantly, though, is the length of the upper lip, which changes according to the expression. Notice how short the upper lip is in the happy expressions here and how long it becomes in surprised or unhappy expressions. In addition, the mouth can be "tugged" to one side, which provides an extra accent. You can add teeth or forget about them, depending on the emotion being expressed, and you can even change the shape of the teeth. Spiked teeth work well in angry expressions but not on worried ones—they look too aggressive.

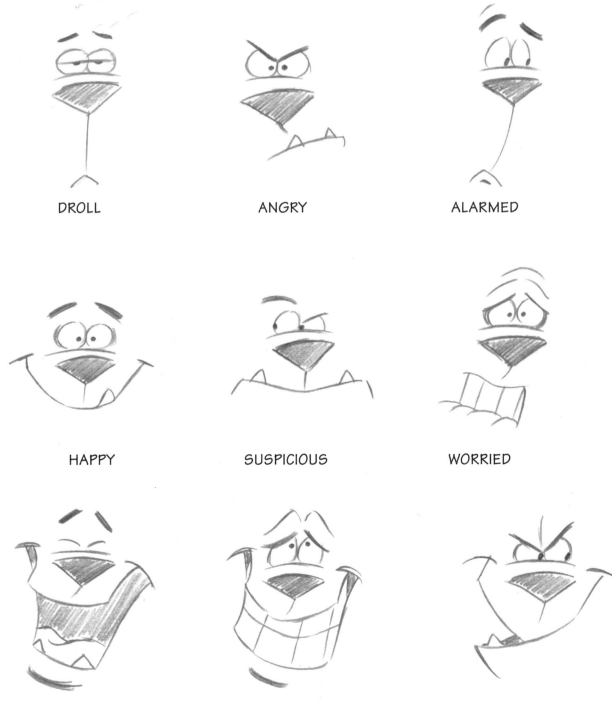

DROLL ANGRY ALARMED

HAPPY SUSPICIOUS WORRIED

LAUGHTER EMBARRASSMENT EVIL GRIN

The Ears

Human ears are attached to the side of the head, but on dogs, as with most animals, the ears appear toward the top and off to the side of the head, at a 45-degree angle.

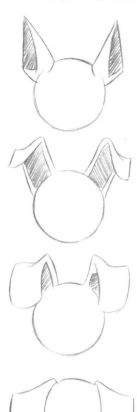

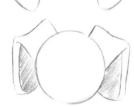

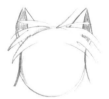

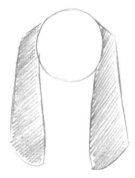

AN ASSORTMENT OF EARS

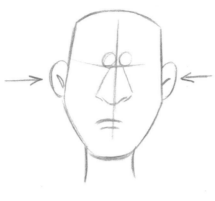

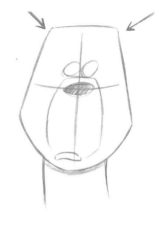

FOLDED EARS

Floppy ears add charm and personality to a dog. Most dog ears fold over, with the exception of short, triangular ears—the kind found on terriers, chow chows, German shepherds, and a few other breeds. The most important thing to remember about drawing the folded ear is that the line from the *base* of the ear must connect to the *outermost* corner of the fold.

RIGHT
The base of the ear connects to the outermost corner of the fold.

WRONG
The base of the ear doesn't connect to anything; it just shoots out into space.

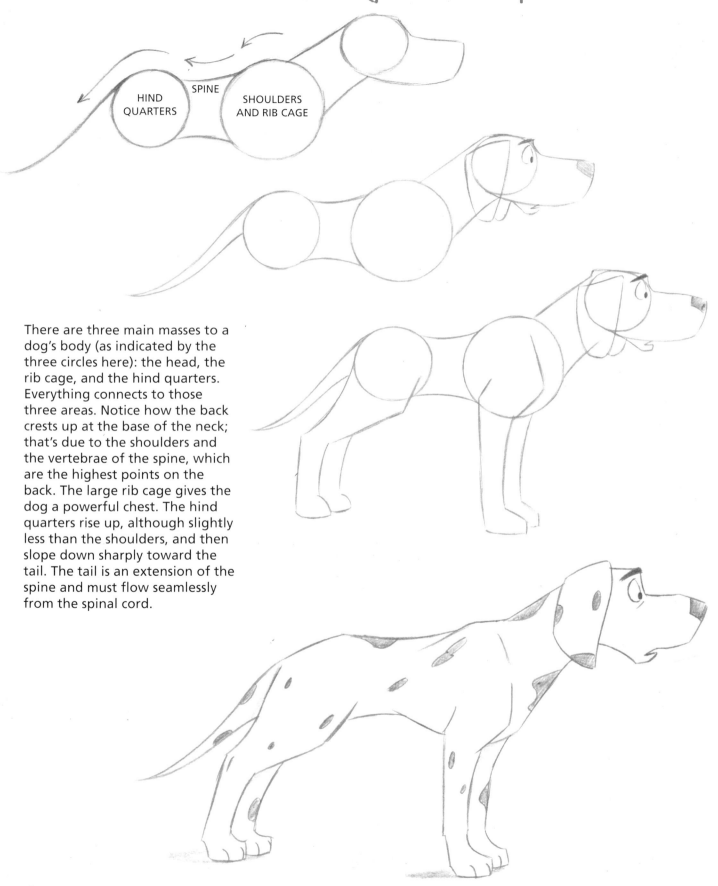

HIND QUARTERS

SPINE

SHOULDERS AND RIB CAGE

There are three main masses to a dog's body (as indicated by the three circles here): the head, the rib cage, and the hind quarters. Everything connects to those three areas. Notice how the back crests up at the base of the neck; that's due to the shoulders and the vertebrae of the spine, which are the highest points on the back. The large rib cage gives the dog a powerful chest. The hind quarters rise up, although slightly less than the shoulders, and then slope down sharply toward the tail. The tail is an extension of the spine and must flow seamlessly from the spinal cord.

Drawing the Body–3/4 View

Due to the principles of perspective, the rib cage, which is closer to us in this pose, will appear *larger* than the hind quarters, which are farther away.

This is the basic form.

Now let's put some character into the face. Start to indicate the front legs (fore legs).

Note that the feet aren't round but have sides to them. I've exaggerated this here to clarify the form.

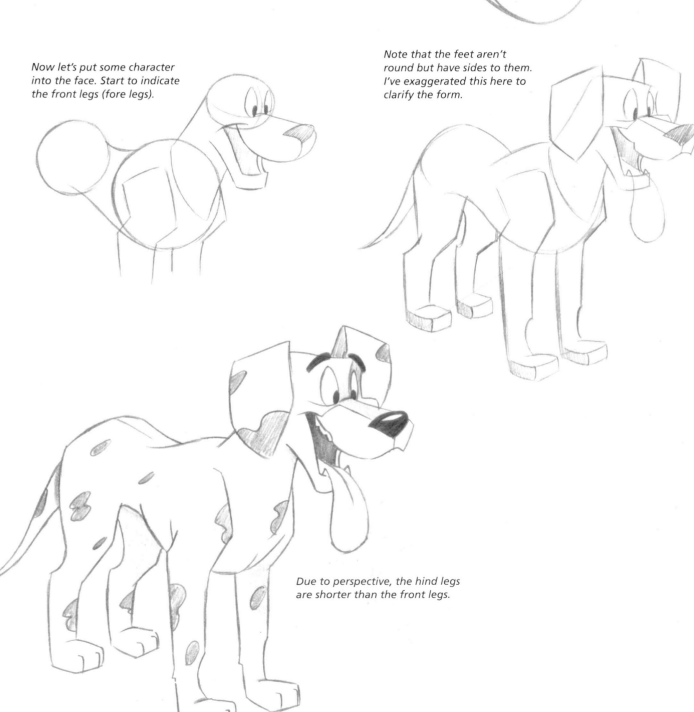

Due to perspective, the hind legs are shorter than the front legs.

The front-view pose confounds many people. In this position, the dog directly faces front, toward the reader. Logic would dictate that you should draw it as I have in this first example. But, logic doesn't always look right. In fact, you should *never* draw a frontal pose like this. It looks flat, and all of those legs sprouting from the body look weird.

What you want to do is something that cartoonists call "cheating." Turn the dog just a hair to the side, while keeping his head facing front. Now, we've got a pose that works. The shoulders slightly overlap the ribs, and the ribs slightly overlap the hips, creating a sense of depth in the pose.

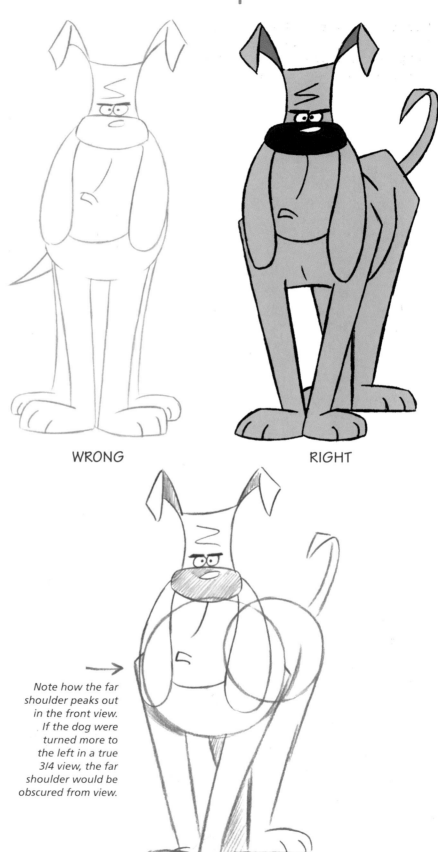

WRONG RIGHT

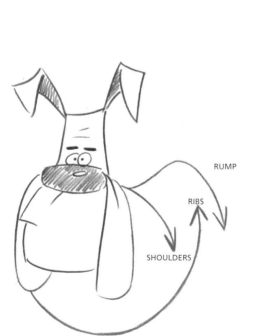

RUMP

RIBS

SHOULDERS

Note the overlapping lines.

→

Note how the far shoulder peaks out in the front view. If the dog were turned more to the left in a true 3/4 view, the far shoulder would be obscured from view.

DOGS WITH PAPERS

These are the classic breeds, the popular types of dogs that fill the movie screens and the comics sections of newspapers—not to mention quite a few backyards in suburbia. The information we've already covered on basic construction will help you to master this section.

Cocker Spaniel

This cocker spaniel is about to battle a moral dilemma, but it doesn't look as though he's going to battle it for long. Whereas real dogs typically shun non-protein based foods, cartoon dogs are usually depicted as having an appetite for everything, especially dessert. The cocker spaniel is best depicted as a loyal pet and as especially good with children which is, in fact, true. It is appealingly shaggy, but not unkempt. The breed loves the outdoors, as well as hearth and home.

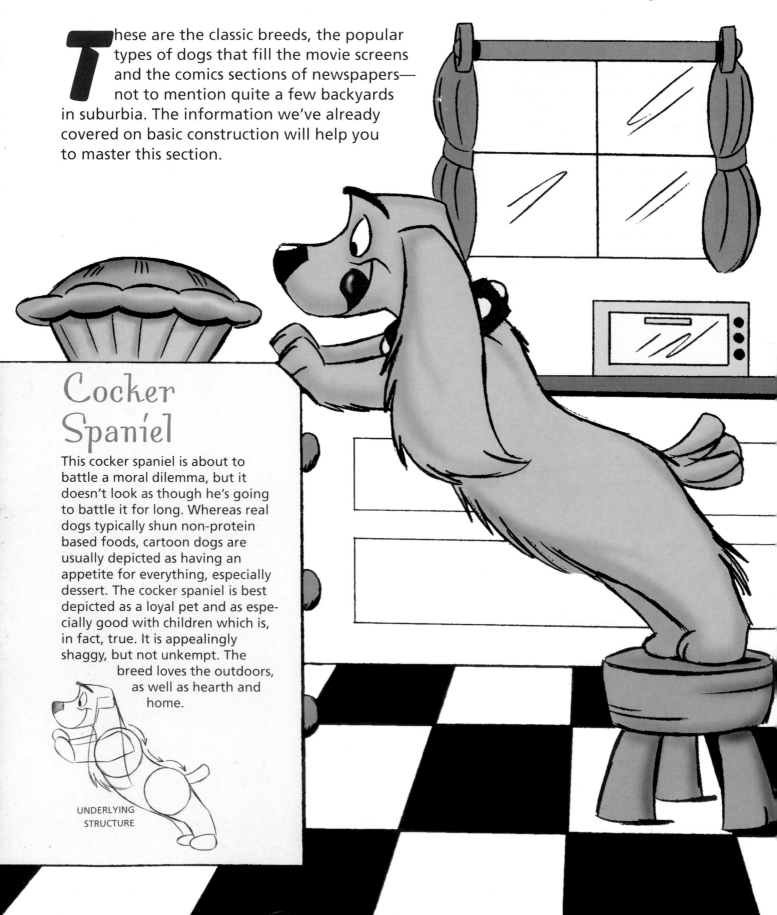

UNDERLYING
STRUCTURE

Small dogs can have robust builds and be remarkably sturdy in stature. Such is the case with the terrier. The neck is surprisingly thick and muscular. The compact little body shows very little in the way of a waistline, and the short legs allow the body to hover just above the ground. Note the distinctive triangular ears. He's also got bushy eyebrows, a bushy mouth, bushy forelegs and hind legs, and small paws. Be sure to show small bottom teeth on this fellow—the breed started out as hunting dogs before acclimating quite nicely to the comforts of apartment life or, if lucky, the penthouse.

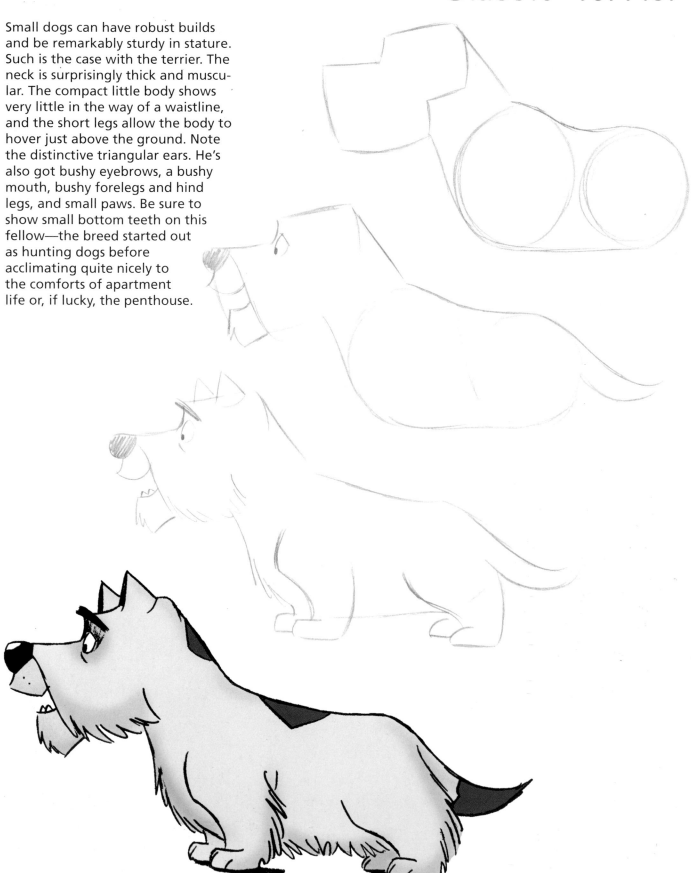

15

Chow Chow

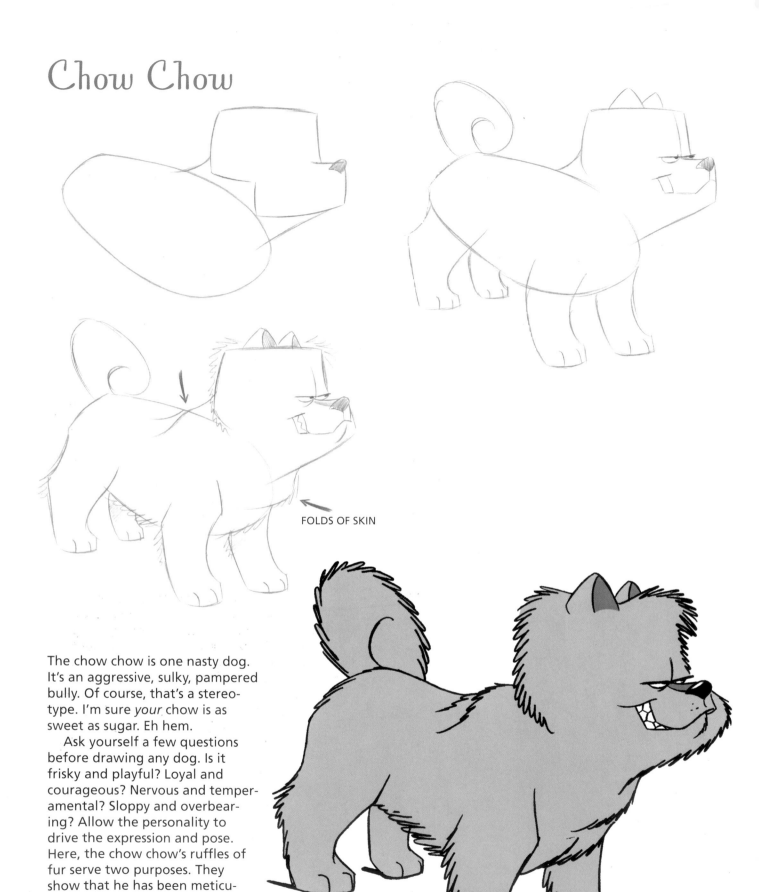

FOLDS OF SKIN

The chow chow is one nasty dog. It's an aggressive, sulky, pampered bully. Of course, that's a stereotype. I'm sure *your* chow is as sweet as sugar. Eh hem.

Ask yourself a few questions before drawing any dog. Is it frisky and playful? Loyal and courageous? Nervous and temperamental? Sloppy and overbearing? Allow the personality to drive the expression and pose. Here, the chow chow's ruffles of fur serve two purposes. They show that he has been meticulously groomed and, therefore, pampered. And, they also show that he still has rough edges. Note the trademark curled tail.

Collie

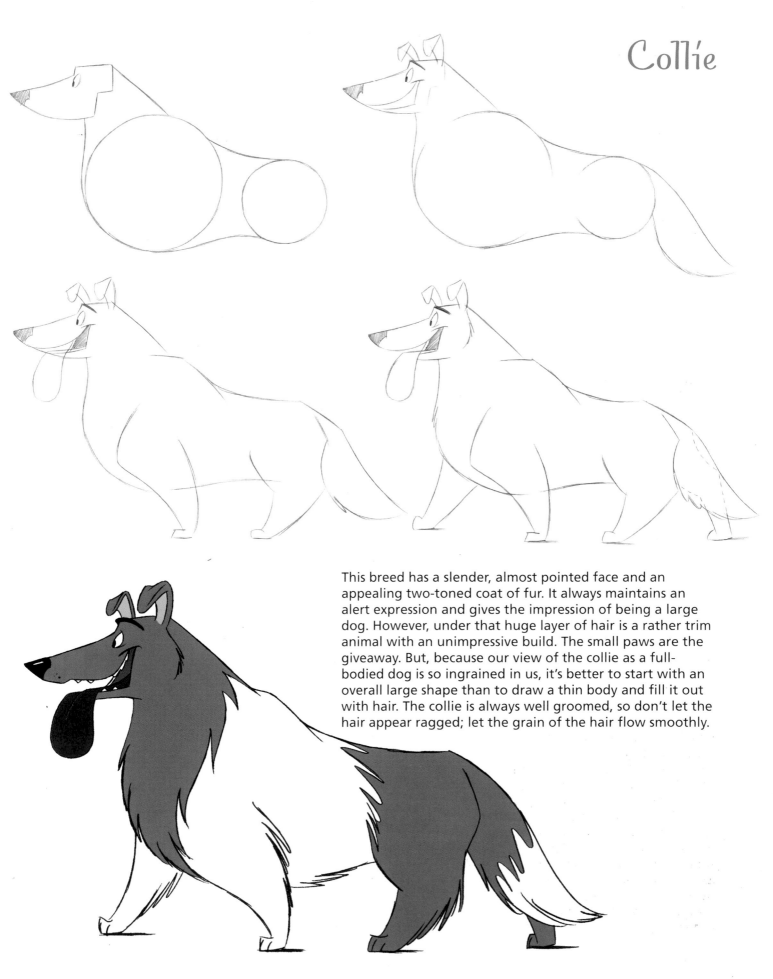

This breed has a slender, almost pointed face and an appealing two-toned coat of fur. It always maintains an alert expression and gives the impression of being a large dog. However, under that huge layer of hair is a rather trim animal with an unimpressive build. The small paws are the giveaway. But, because our view of the collie as a full-bodied dog is so ingrained in us, it's better to start with an overall large shape than to draw a thin body and fill it out with hair. The collie is always well groomed, so don't let the hair appear ragged; let the grain of the hair flow smoothly.

Doberman Pinscher

The Doberman pinscher is the mako shark of the dog kingdom. Its large chest and narrow hips give it an angular, hard look. Its small skull, short forehead, and thick, muscular neck combine to give it a vicious demeanor. Note the short, docked tail. The coloring is always reddish brown and black, or simply reddish brown. A reddish-brown Doberman can have a red nose.

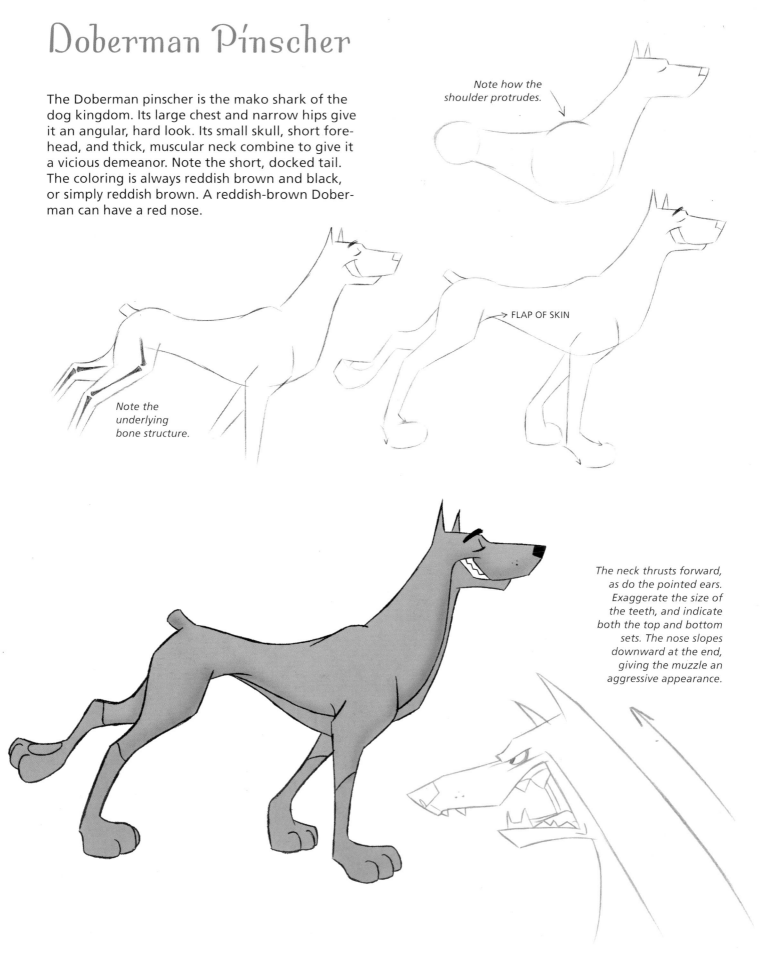

Note how the shoulder protrudes.

FLAP OF SKIN

Note the underlying bone structure.

The neck thrusts forward, as do the pointed ears. Exaggerate the size of the teeth, and indicate both the top and bottom sets. The nose slopes downward at the end, giving the muzzle an aggressive appearance.

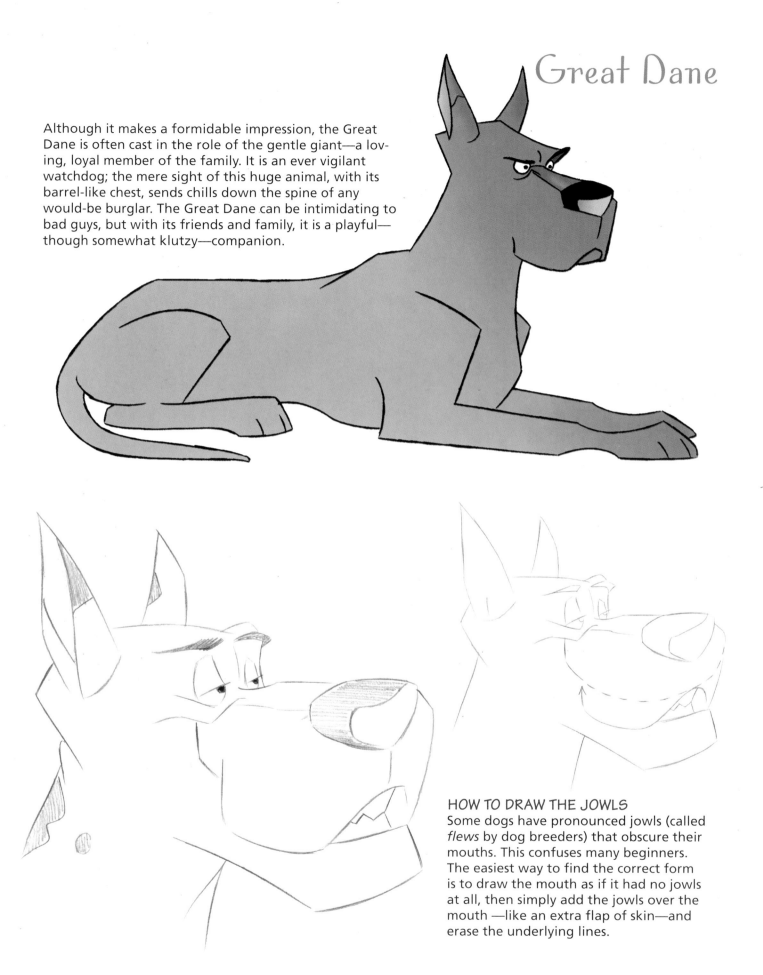

Great Dane

Although it makes a formidable impression, the Great Dane is often cast in the role of the gentle giant—a loving, loyal member of the family. It is an ever vigilant watchdog; the mere sight of this huge animal, with its barrel-like chest, sends chills down the spine of any would-be burglar. The Great Dane can be intimidating to bad guys, but with its friends and family, it is a playful—though somewhat klutzy—companion.

HOW TO DRAW THE JOWLS
Some dogs have pronounced jowls (called *flews* by dog breeders) that obscure their mouths. This confuses many beginners. The easiest way to find the correct form is to draw the mouth as if it had no jowls at all, then simply add the jowls over the mouth —like an extra flap of skin—and erase the underlying lines.

Bullmastiff

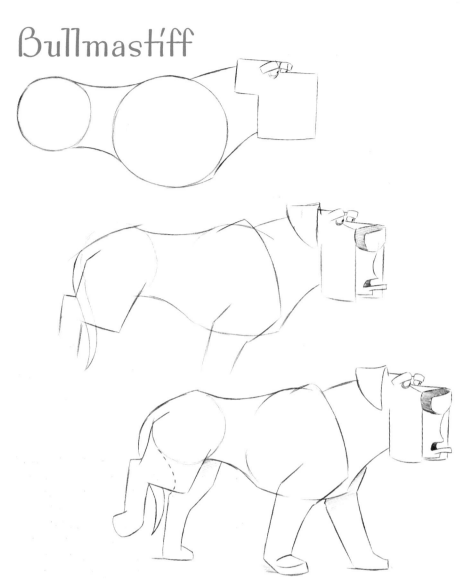

This is a powerfully built dog that was initially used for hunting, but it is also a lovable household pet with a good disposition. Its distinctive features include a large muzzle with an underbite and flapping jowls. It has a wrinkled, flat forehead and short, flopping ears. The skin is loose with folds, especially around the neck. The paws are rather thick, and the legs are quite sturdy.

In cartoons, the larger dogs, such as the bullmastiff and the Great Dane, are best depicted with slower personalities—sweet but dim. The smaller the dog, the more nervous its personality; the bigger the dog, the more docile.

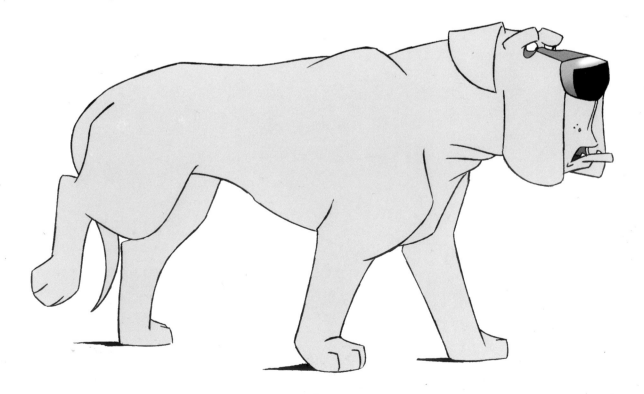

German Shepherd

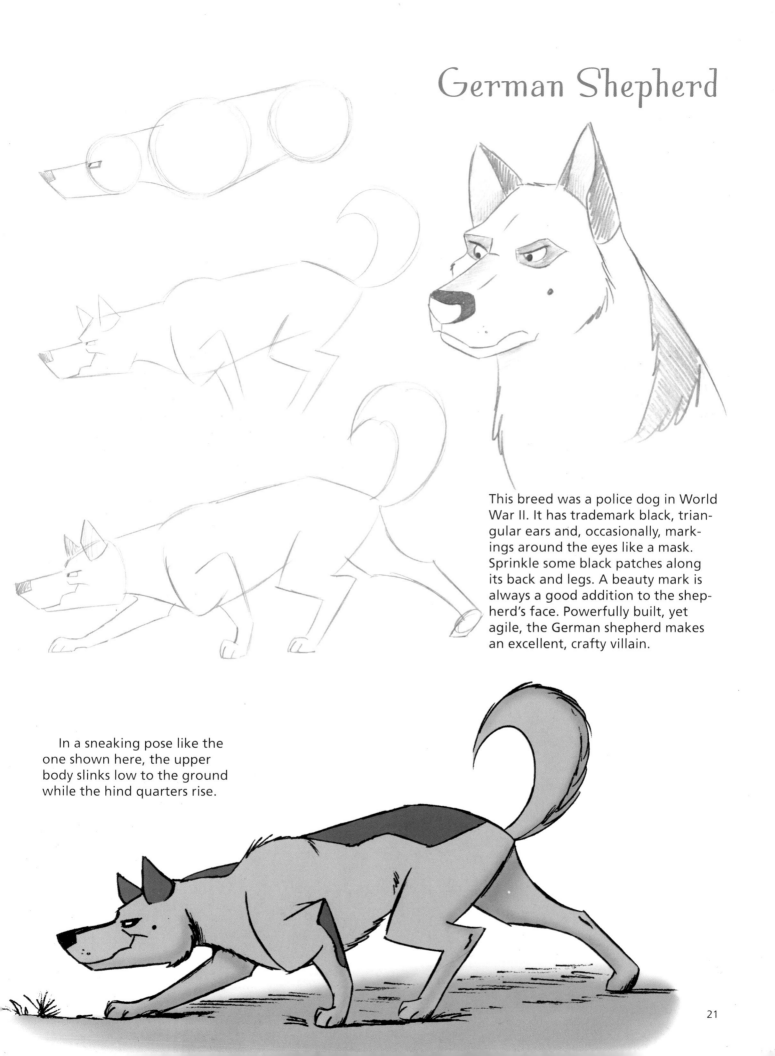

This breed was a police dog in World War II. It has trademark black, triangular ears and, occasionally, markings around the eyes like a mask. Sprinkle some black patches along its back and legs. A beauty mark is always a good addition to the shepherd's face. Powerfully built, yet agile, the German shepherd makes an excellent, crafty villain.

In a sneaking pose like the one shown here, the upper body slinks low to the ground while the hind quarters rise.

Saint Bernard

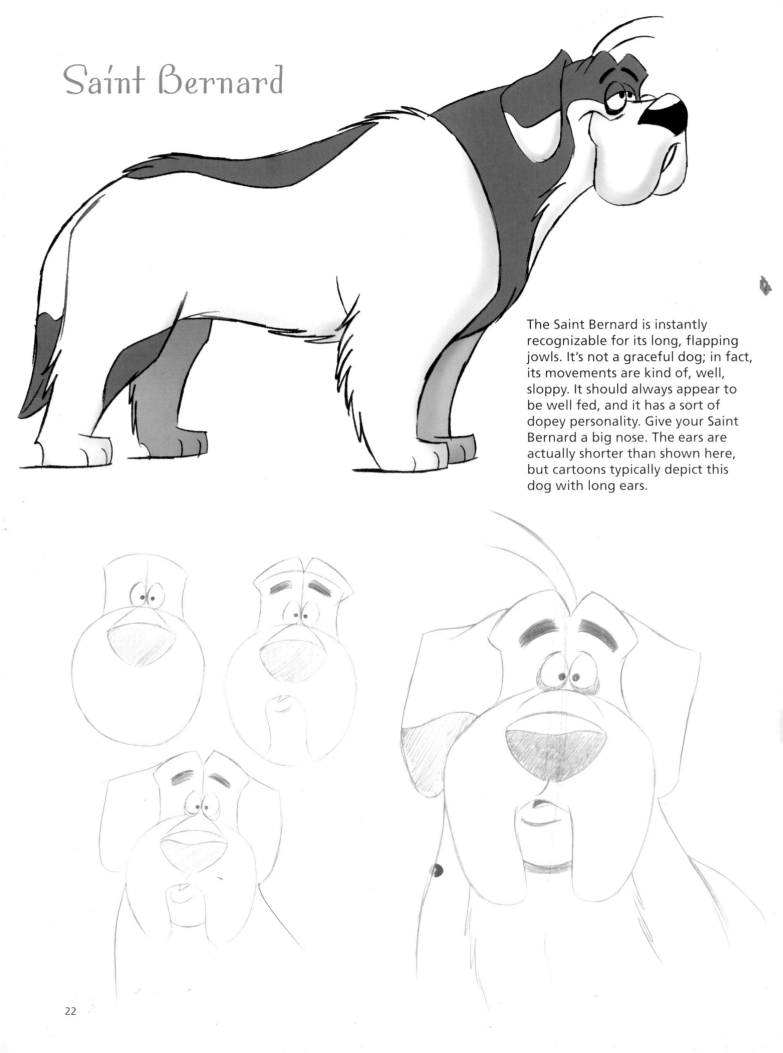

The Saint Bernard is instantly recognizable for its long, flapping jowls. It's not a graceful dog; in fact, its movements are kind of, well, sloppy. It should always appear to be well fed, and it has a sort of dopey personality. Give your Saint Bernard a big nose. The ears are actually shorter than shown here, but cartoons typically depict this dog with long ears.

Maltese

Categorized as a *toy* dog because of its diminutive size, the Maltese has totally adapted to indoor living. "Toys" are pampered, and this should show in your drawings. They have ridiculous haircuts that are so long they require constant grooming. Give them ribbons, or even jewelry. Remember, it's blue ribbons for "boys," and red or pink for "girls." Designer doggy clothes can also be part of a toy's wardrobe, as it gets cold easily. The male toy is never brave, but usually hangs out with a larger companion dog who acts as its bodyguard or mentor. The female is more at home on someone's lap than in a backyard.

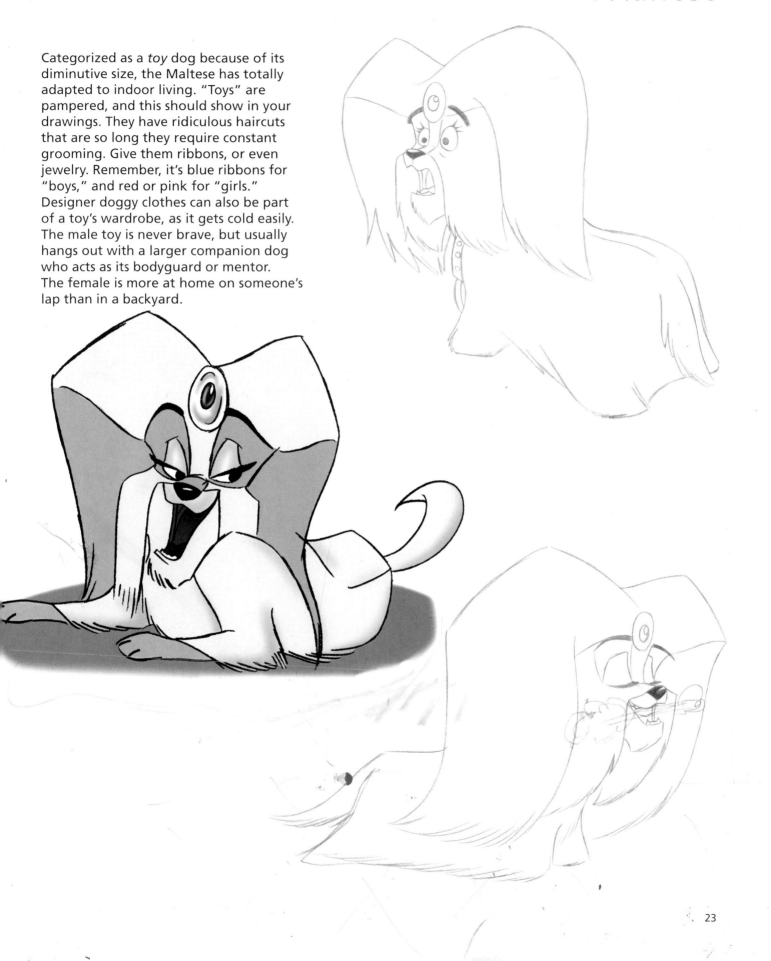

Chihuahua

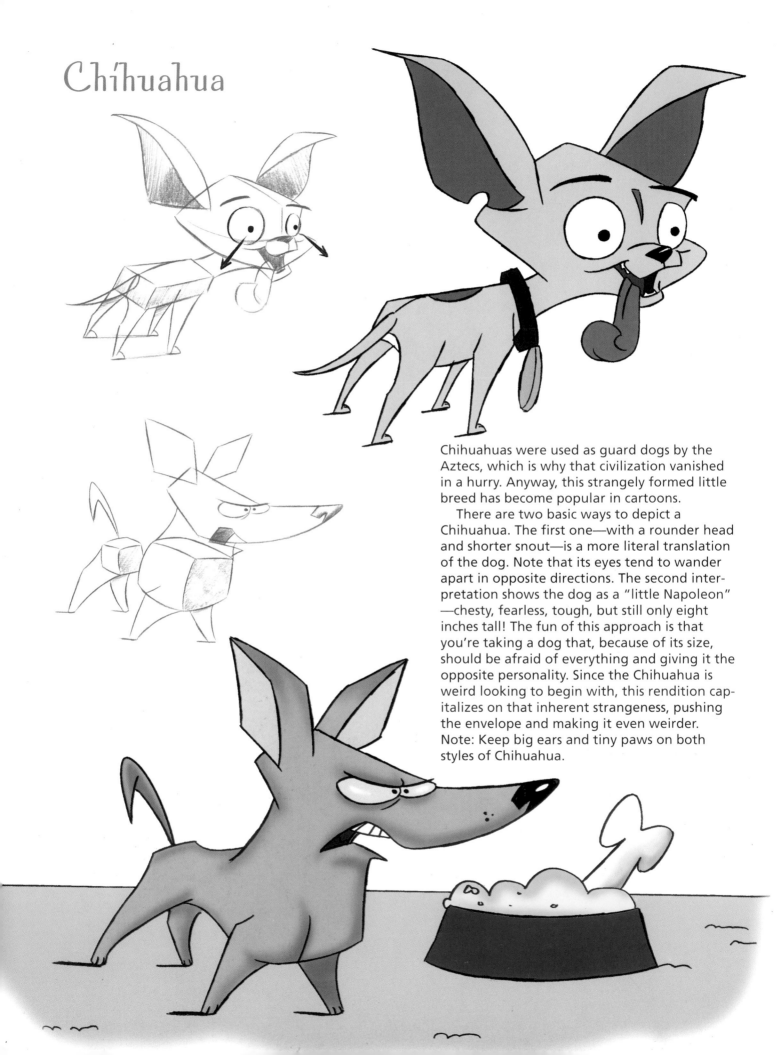

Chihuahuas were used as guard dogs by the Aztecs, which is why that civilization vanished in a hurry. Anyway, this strangely formed little breed has become popular in cartoons.

There are two basic ways to depict a Chihuahua. The first one—with a rounder head and shorter snout—is a more literal translation of the dog. Note that its eyes tend to wander apart in opposite directions. The second interpretation shows the dog as a "little Napoleon" —chesty, fearless, tough, but still only eight inches tall! The fun of this approach is that you're taking a dog that, because of its size, should be afraid of everything and giving it the opposite personality. Since the Chihuahua is weird looking to begin with, this rendition capitalizes on that inherent strangeness, pushing the envelope and making it even weirder. Note: Keep big ears and tiny paws on both styles of Chihuahua.

Bulldog: King of the Cartoon Bad Guys

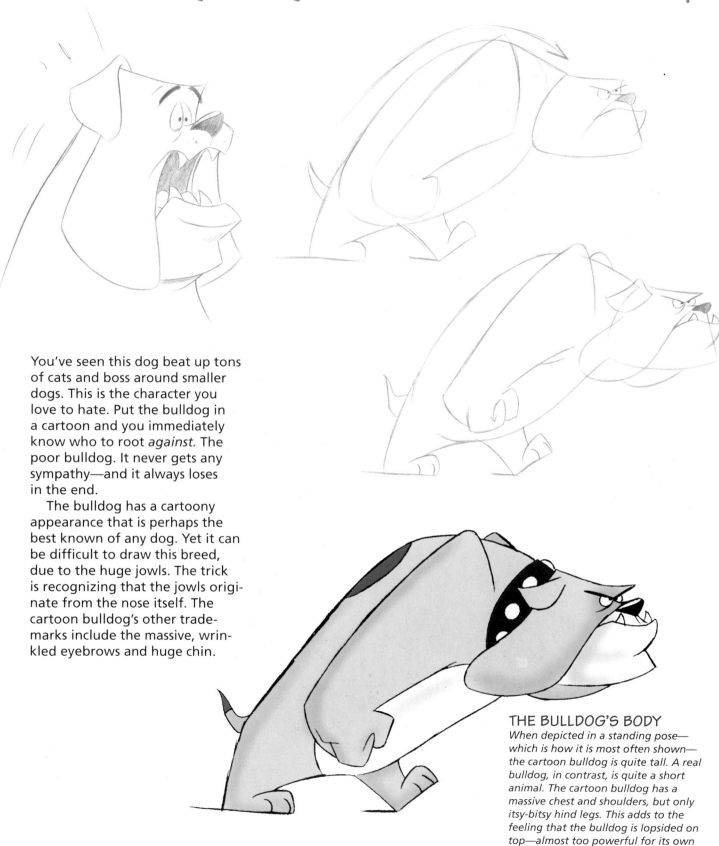

You've seen this dog beat up tons of cats and boss around smaller dogs. This is the character you love to hate. Put the bulldog in a cartoon and you immediately know who to root *against*. The poor bulldog. It never gets any sympathy—and it always loses in the end.

The bulldog has a cartoony appearance that is perhaps the best known of any dog. Yet it can be difficult to draw this breed, due to the huge jowls. The trick is recognizing that the jowls originate from the nose itself. The cartoon bulldog's other trademarks include the massive, wrinkled eyebrows and huge chin.

THE BULLDOG'S BODY
When depicted in a standing pose—which is how it is most often shown—the cartoon bulldog is quite tall. A real bulldog, in contrast, is quite a short animal. The cartoon bulldog has a massive chest and shoulders, but only itsy-bitsy hind legs. This adds to the feeling that the bulldog is lopsided on top—almost too powerful for its own good. Its tiny tail is short and crooked.

Old English Sheepdog

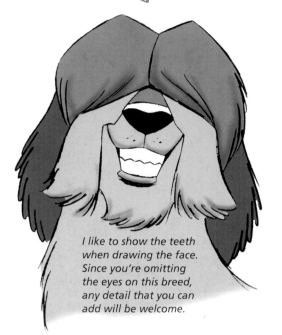

I like to show the teeth when drawing the face. Since you're omitting the eyes on this breed, any detail that you can add will be welcome.

Start with a kidney bean shape. Exaggerate the slope of the back. Without that slope, the torso becomes one mass. Since the sheepdog is covered in fur, it will tend to look like a lump unless you fight against it.

Never, ever show the eyes of a sheepdog! They should forever remain under a floppy mound of shaggy hair. The sheepdog's body is also hidden under that shaggy carpet, but the drawing will look far more convincing if you rough out the underlying construction first.

Draw the forelegs and hind legs with soft, rounded angles.

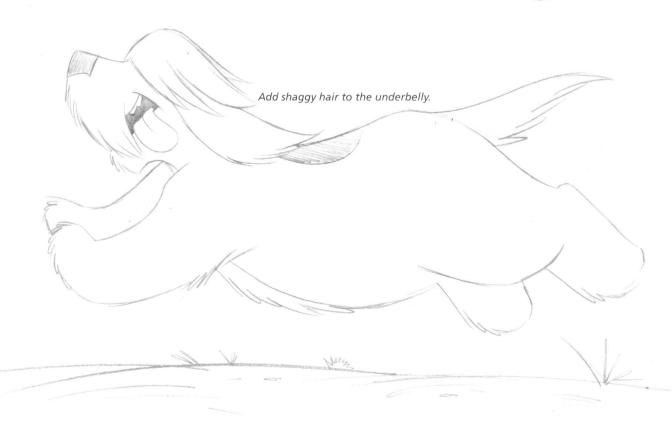

Add shaggy hair to the underbelly.

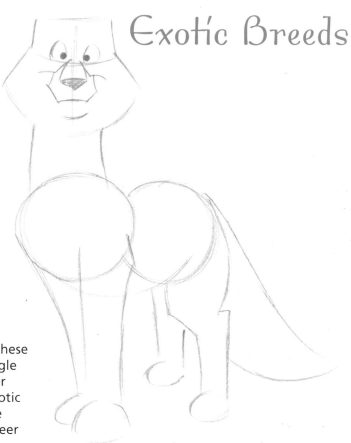

There are so many breeds of dogs that it sometimes seems as though new ones are being created and accredited every day. Most people haven't heard of these exotic types, but they're just as appealing as the beagle and the Great Dane. If you want to create a character that is a little unique, look into some of the more exotic breeds, especially those from foreign countries. Since most people won't recognize these dogs, you'll be freer to take more liberties in designing them.

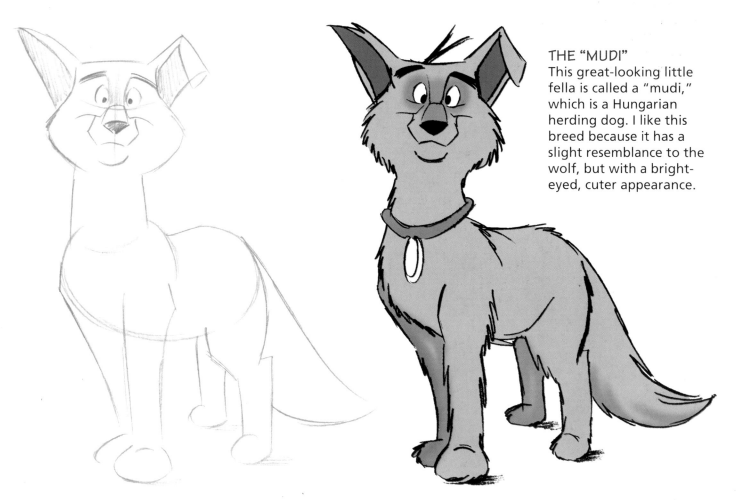

THE "MUDI"
This great-looking little fella is called a "mudi," which is a Hungarian herding dog. I like this breed because it has a slight resemblance to the wolf, but with a bright-eyed, cuter appearance.

ANATOMY AND OTHER COOL STUFF

Don't be intimidated by anatomy. As you progress in your drawing, these things will become second nature to you. Until then, you have this book to turn to for reference anytime you get stuck or just need a reminder.

I've chosen a whippet—in the greyhound family—to show off basic dog bone structure because it's such a sleek and slender dog that its underlying skeleton isn't obscured by fat or fur.

There are a few basic things to look for when studying a dog's skeleton as it relates to drawing and cartooning. Notice how the shape of the dog's shoulders, forelegs, hind legs, and rib cage are all dictated by the underlying bone structure. By comparing the skeleton to the finished dog, you can see firsthand how the shoulder blade and vertebrae, for example, stick up to cause that bump at the base of a dog's neck. The red arrows compare the height of the "heel" to that of the "wrist." As you can see, the heel is higher than the wrist on a dog. Try to commit that one to memory. And, see how the heel bone sticks out? That's why a dog's back legs seem to jut out.

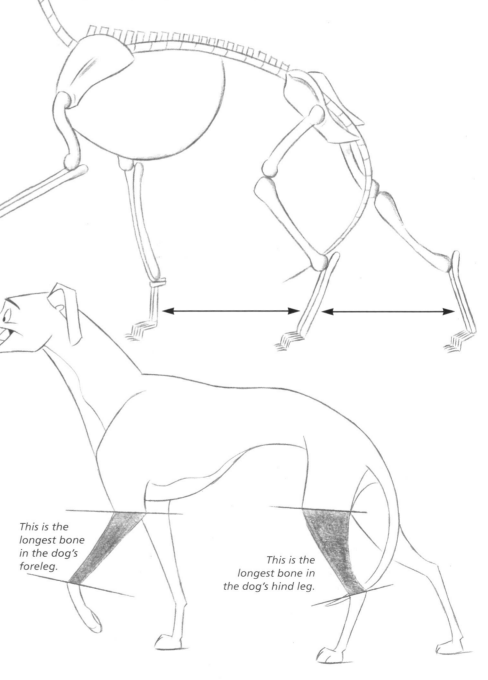

This is the longest bone in the dog's foreleg.

This is the longest bone in the dog's hind leg.

Why Dogs' Joints Bend the Way They Do

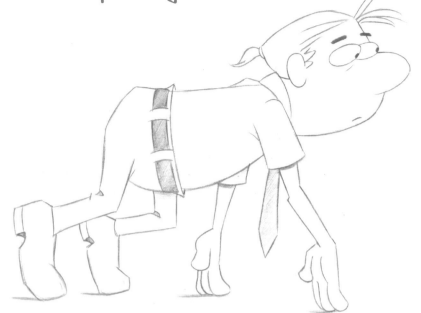

Dogs don't walk on the equivalent of their "hands" and "feet." Dogs walk on their fingers and toes. That's right. Their heels (the part most people *incorrectly* assume is a backward-bending knee) stick up in the air when they walk or stand. The best way to make sense of canine joint configuration is to compare it to that of a person in precisely the same pose. The illustrations here show exactly how humans would have to walk, if they were to walk like dogs.

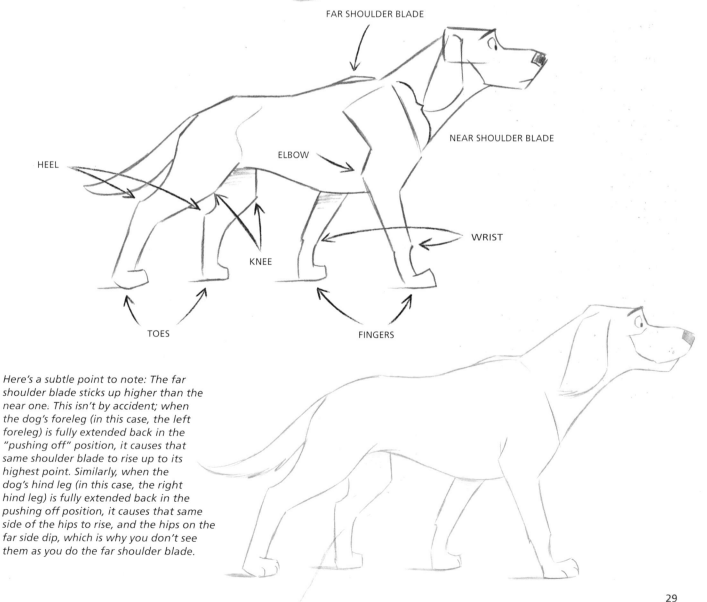

FAR SHOULDER BLADE

NEAR SHOULDER BLADE

ELBOW

HEEL

WRIST

KNEE

TOES

FINGERS

Here's a subtle point to note: The far shoulder blade sticks up higher than the near one. This isn't by accident; when the dog's foreleg (in this case, the left foreleg) is fully extended back in the "pushing off" position, it causes that same shoulder blade to rise up to its highest point. Similarly, when the dog's hind leg (in this case, the right hind leg) is fully extended back in the pushing off position, it causes that same side of the hips to rise, and the hips on the far side dip, which is why you don't see them as you do the far shoulder blade.

Using the Skeleton to Understand Contours

On the surface of a dog's form, you'll see contour lines around the hips and shoulders.

"But what do they stand for, and how will I know where to draw them?" you ask.

The answer is that the contour lines roughly follow the skeleton.

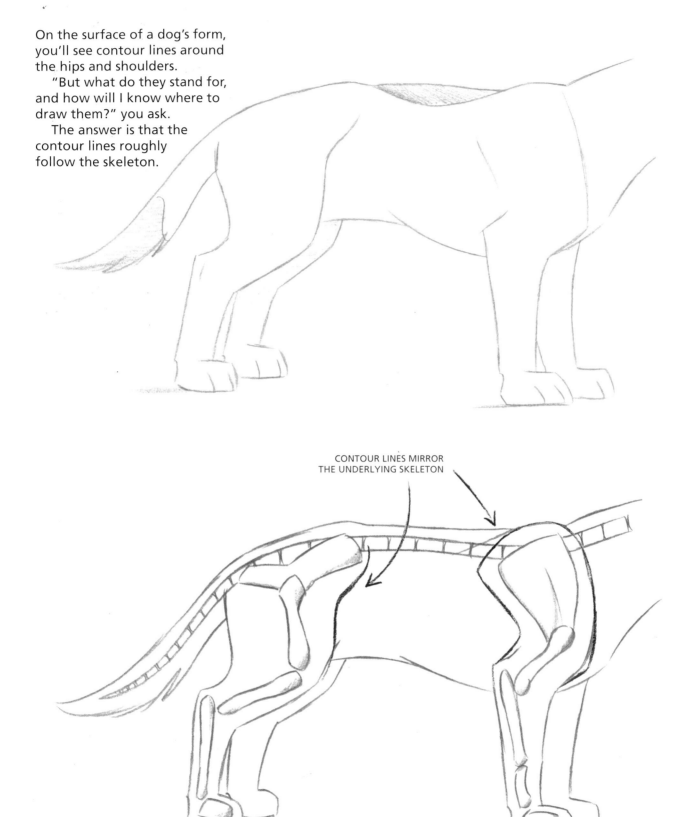

CONTOUR LINES MIRROR
THE UNDERLYING SKELETON

The Underlying Bone Structure

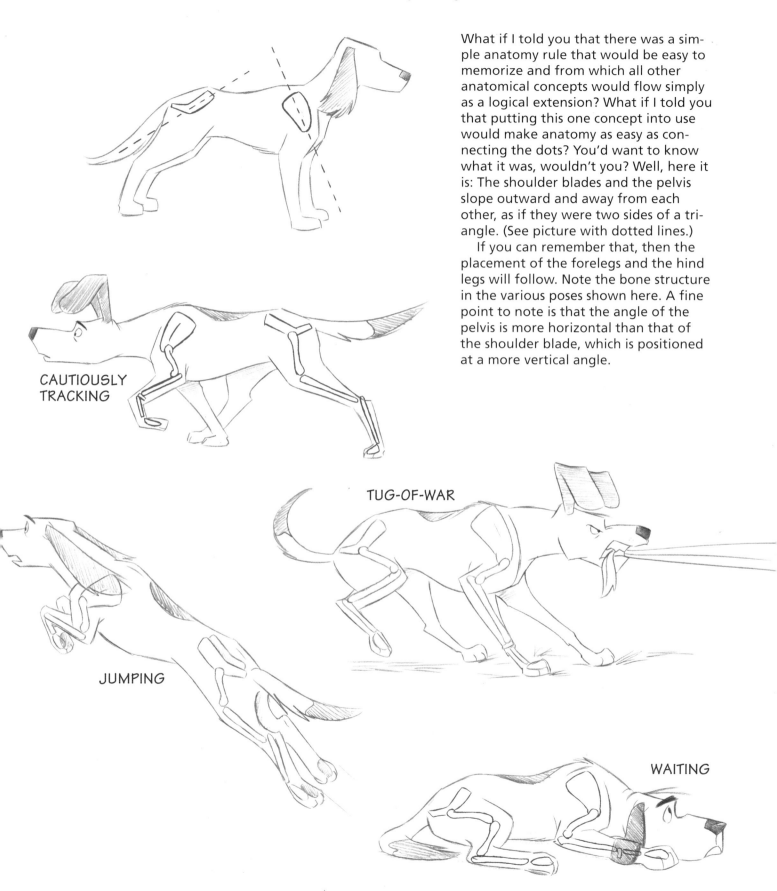

What if I told you that there was a simple anatomy rule that would be easy to memorize and from which all other anatomical concepts would flow simply as a logical extension? What if I told you that putting this one concept into use would make anatomy as easy as connecting the dots? You'd want to know what it was, wouldn't you? Well, here it is: The shoulder blades and the pelvis slope outward and away from each other, as if they were two sides of a triangle. (See picture with dotted lines.)

If you can remember that, then the placement of the forelegs and the hind legs will follow. Note the bone structure in the various poses shown here. A fine point to note is that the angle of the pelvis is more horizontal than that of the shoulder blade, which is positioned at a more vertical angle.

CAUTIOUSLY TRACKING

TUG-OF-WAR

JUMPING

WAITING

How a Dog Walks

This is a complete sequence of a dog's walk. If you want to draw a dog in a walking pose, you can choose any of the positions in the sequence as the basis for your pose. However, if you want to go a step further and understand the mechanics of the entire walk cycle, it's not as tricky as it looks—once you know what to look for. And, just like riding a bicycle, once you know it, you'll never forget it.

The dog steps with a hind leg first. When that hind leg makes contact with the ground, only then does the dog move the foreleg on the *same* side forward a step. It's that simple. Back leg, front leg on the same side. Then back leg, front leg on the other side. Look at one side at a time, not all four limbs at once. Scan your eyes across this sequence and try to see it animate in your mind's eye. This is a typical animation *walk cycle,* which means that drawing number 6 leads into drawing number 1, and the entire sequence can be repeated over and over and over again.

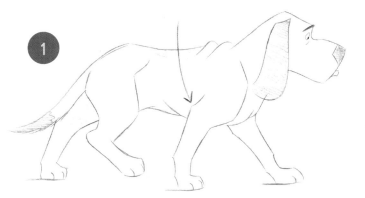

When the foreleg is in the back position, the "elbow" rises above the rib cage, but when it is outstretched in front of the dog, the elbow dips below the rib cage (see drawing 4).

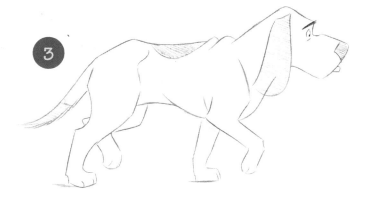

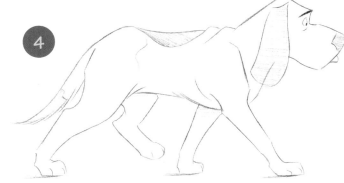

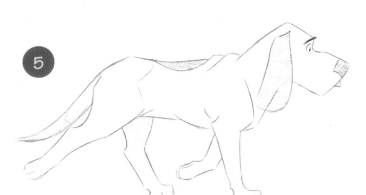

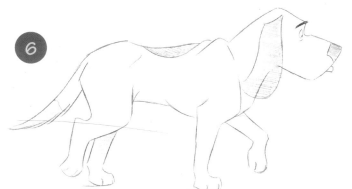

The foot placement of dogs changes when they shift from walking to running, and this placement is different from that of a running cat or horse. When dogs run, they place their feet in a sequence, one after the other, in either a clockwise or a counterclockwise rotation. The example here shows a counterclockwise motion. So, if a dog begins its run

(called a *gallop*) by landing on its right foreleg, it would land on its left foreleg next, then on its left hind leg, and then on its right hind leg. The cycle repeats itself, and this is aptly called a *rotary gallop.* You can start the cycle anywhere in the sequence, as long as it continues along a clockwise or counterclockwise rotation.

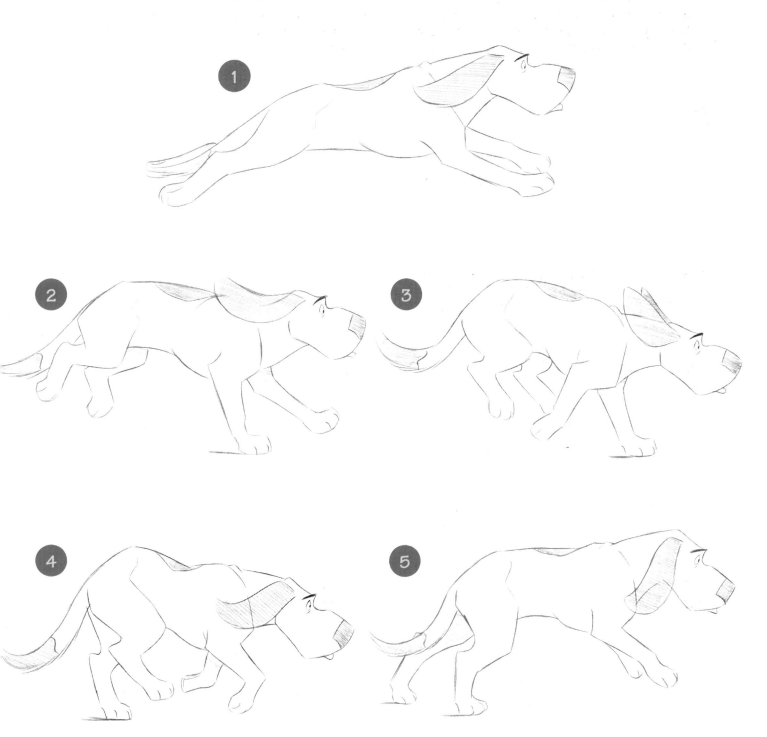

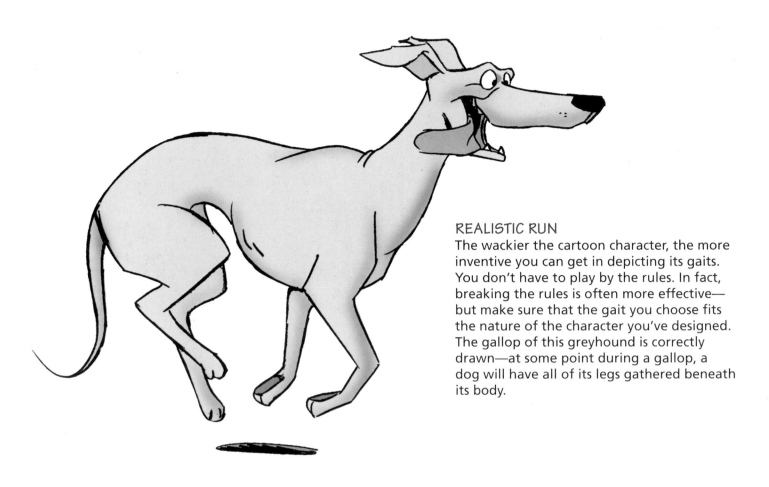

REALISTIC RUN

The wackier the cartoon character, the more inventive you can get in depicting its gaits. You don't have to play by the rules. In fact, breaking the rules is often more effective—but make sure that the gait you choose fits the nature of the character you've designed. The gallop of this greyhound is correctly drawn—at some point during a gallop, a dog will have all of its legs gathered beneath its body.

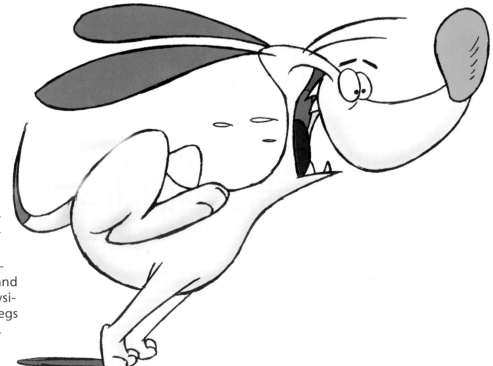

WACKY RUN

This wackier dog, however, is doing a completely made-up, silly run, which works much better for his zany appearance. Silly gallops usually depict a dog's forelegs hitting the ground simultaneously, and likewise with its hind legs. It's physically impossible for a dog's hind legs to rise up as high as they do here, but that's what makes this pose so entertaining.

When dogs walk, their hips and shoulders sway from left to right, contracting (crushing) and expanding (stretching) the opposite sides of the body. Depicting this action in your drawings will prevent your poses from appearing stiff and flat. Here's the rule of thumb: A dog's shoulders and hips sway in the direction of the leg that is extended back. This gives the impression that the front half and the rear half of the body are being pulled away from each other. To understand this, take a look at these dynamics in action.

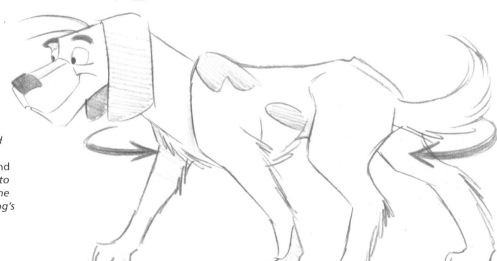

Here, the dog's right foreleg is back; therefore, the dog's head and shoulders sway to the right side. The left hind leg is also extended back, and therefore the hips sway to the left. At this stage of the walk, the left side of the dog's body is stretching and is in an "open" position.

Here, the dog's left foreleg is extended back, which means that the head and shoulders lean to the left. The right hind leg is extended back, so the hips sway to the right, allowing us to see more of the base of the tail. In this drawing, the dog's left foreleg and hind leg are close together, crushing the ribs and hips together in a "closed" position.

Creating Flowing Lines

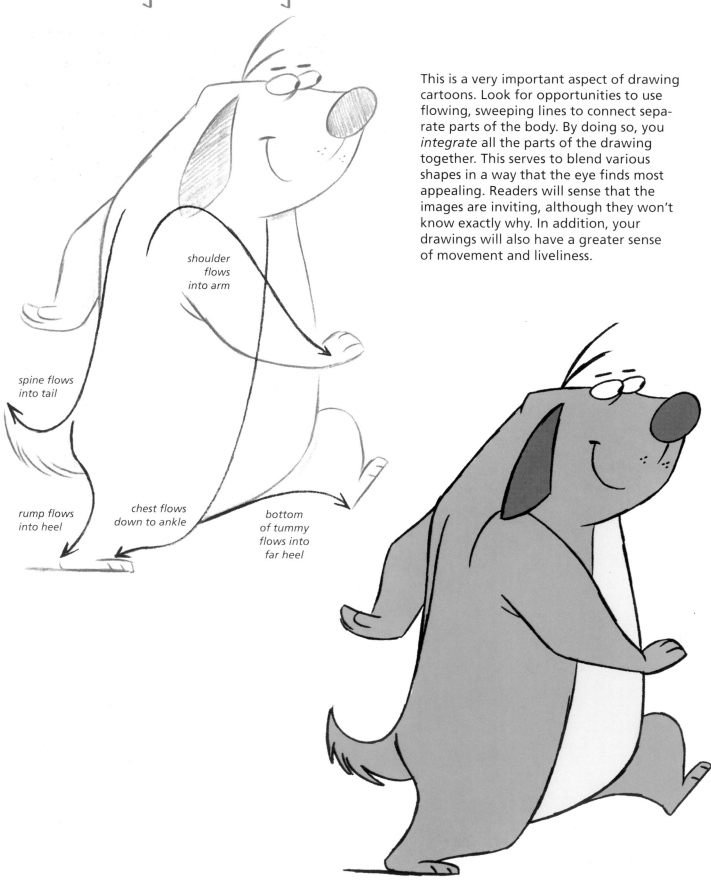

This is a very important aspect of drawing cartoons. Look for opportunities to use flowing, sweeping lines to connect separate parts of the body. By doing so, you *integrate* all the parts of the drawing together. This serves to blend various shapes in a way that the eye finds most appealing. Readers will sense that the images are inviting, although they won't know exactly why. In addition, your drawings will also have a greater sense of movement and liveliness.

shoulder flows into arm

spine flows into tail

rump flows into heel

chest flows down to ankle

bottom of tummy flows into far heel

The Line of Action

When I look at the sketchbooks of aspiring cartoonists and artists, if there is a deficiency it's that the illustrations don't convey a sense of thrust. The artists have worked very hard on the eyes, the head, the muscles, and so on, but there is no *flow* to the drawings. They have no *direction.* The characters are just jumbles of parts and, therefore, are stiff. It's certainly important to master draw ing those individual parts. No doubt about it. But, the parts need an overall framework in which to exist. That's where the *line of action* comes into play.

LINE OF
ACTION

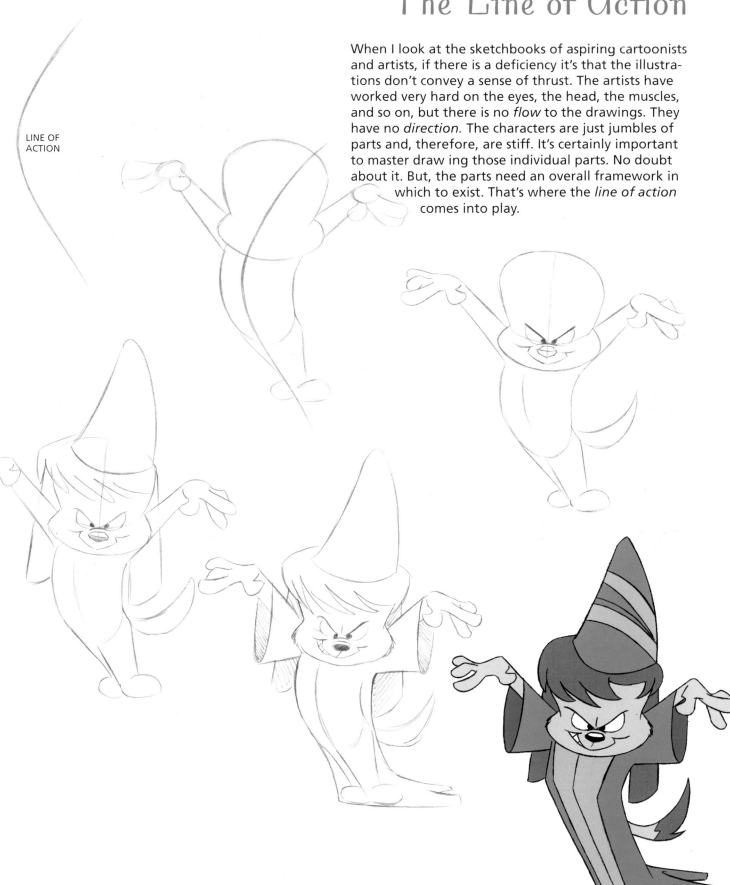

Begin your drawing with a single
line that sweeps or bends in the
general direction of the pose you
wish to create. Even if a character
is merely sitting or standing, the line
of action is a vital ingredient. Draw
your character along the line of
action, being careful to adhere to
that basic thrust. The line of action
can be straight, or it can whip
around, depending on the pose.
Here are a few examples.

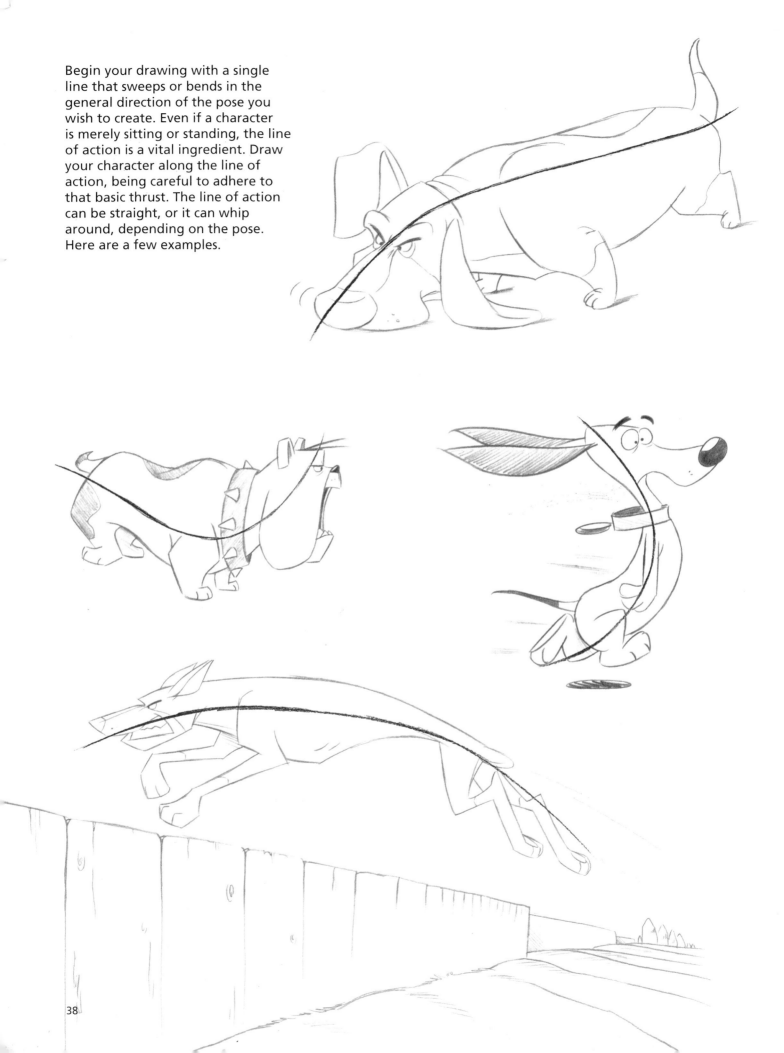

The Spine Line

A dog's spine is very close to the overlying skin of the back, and as a result, the spine can partially show under the skin. By indicating the line of the spine as it curves around the back, you reinforce the idea that the back is round.

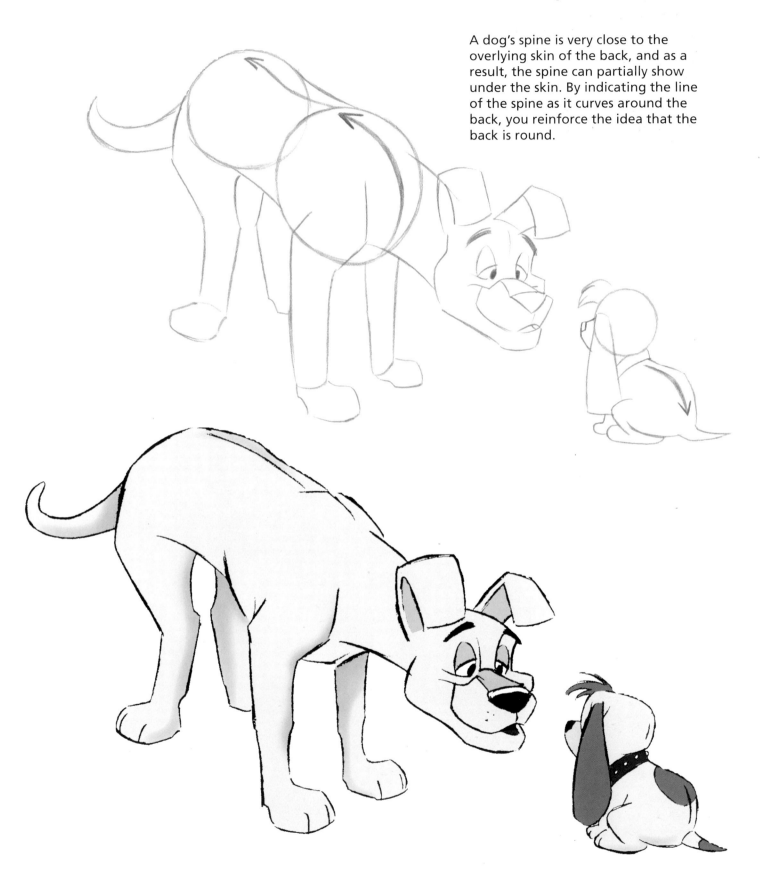

PUPPIES

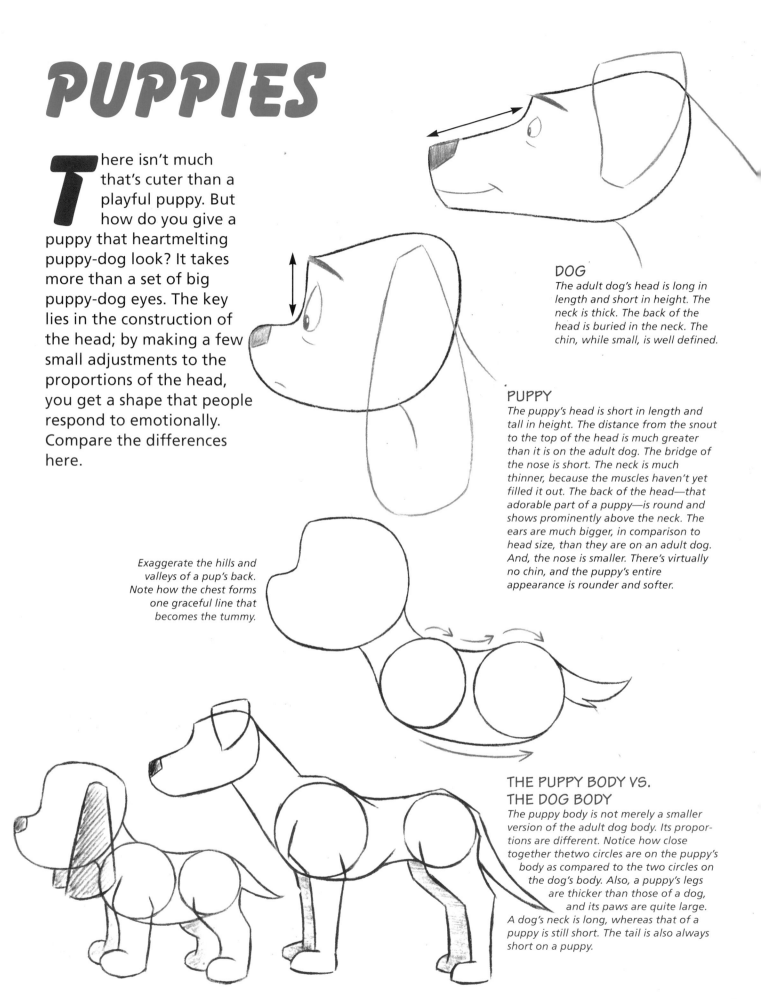

There isn't much that's cuter than a playful puppy. But how do you give a puppy that heartmelting puppy-dog look? It takes more than a set of big puppy-dog eyes. The key lies in the construction of the head; by making a few small adjustments to the proportions of the head, you get a shape that people respond to emotionally. Compare the differences here.

Exaggerate the hills and valleys of a pup's back. Note how the chest forms one graceful line that becomes the tummy.

DOG
The adult dog's head is long in length and short in height. The neck is thick. The back of the head is buried in the neck. The chin, while small, is well defined.

PUPPY
The puppy's head is short in length and tall in height. The distance from the snout to the top of the head is much greater than it is on the adult dog. The bridge of the nose is short. The neck is much thinner, because the muscles haven't yet filled it out. The back of the head—that adorable part of a puppy—is round and shows prominently above the neck. The ears are much bigger, in comparison to head size, than they are on an adult dog. And, the nose is smaller. There's virtually no chin, and the puppy's entire appearance is rounder and softer.

THE PUPPY BODY VS. THE DOG BODY
The puppy body is not merely a smaller version of the adult dog body. Its proportions are different. Notice how close together the two circles are on the puppy's body as compared to the two circles on the dog's body. Also, a puppy's legs are thicker than those of a dog, and its paws are quite large. A dog's neck is long, whereas that of a puppy is still short. The tail is also always short on a puppy.

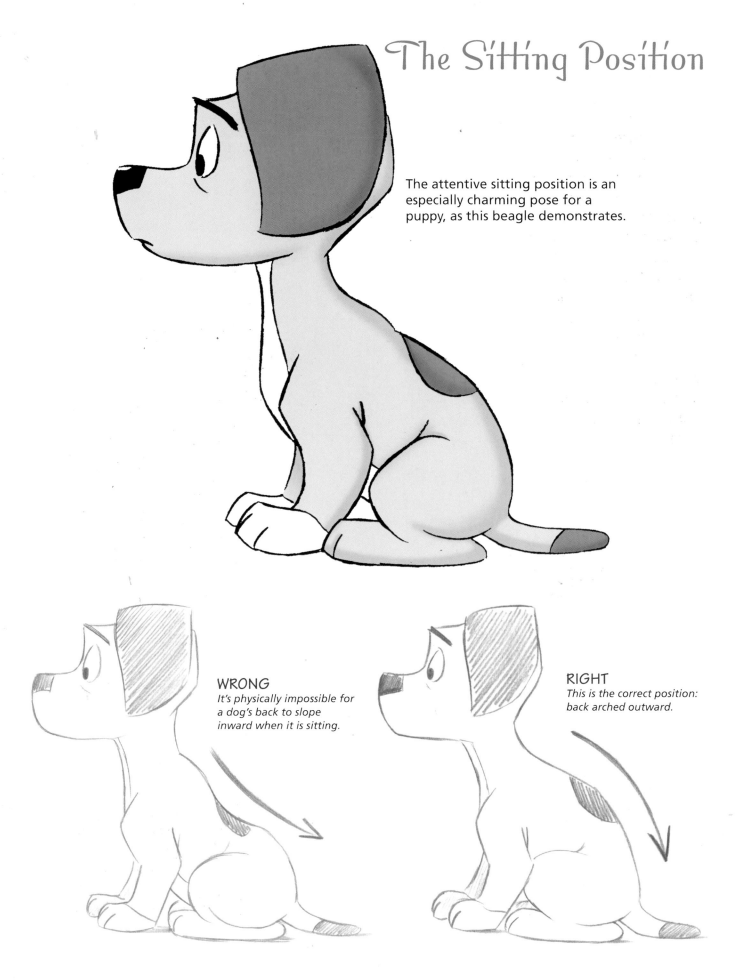

The Sitting Position

The attentive sitting position is an especially charming pose for a puppy, as this beagle demonstrates.

WRONG
It's physically impossible for a dog's back to slope inward when it is sitting.

RIGHT
This is the correct position: back arched outward.

The Running Puppy

The roundness of a puppy makes it easier to draw than a mature dog. Notice how the ears flap back during the run. A puppy runs with a floppy exuberance.

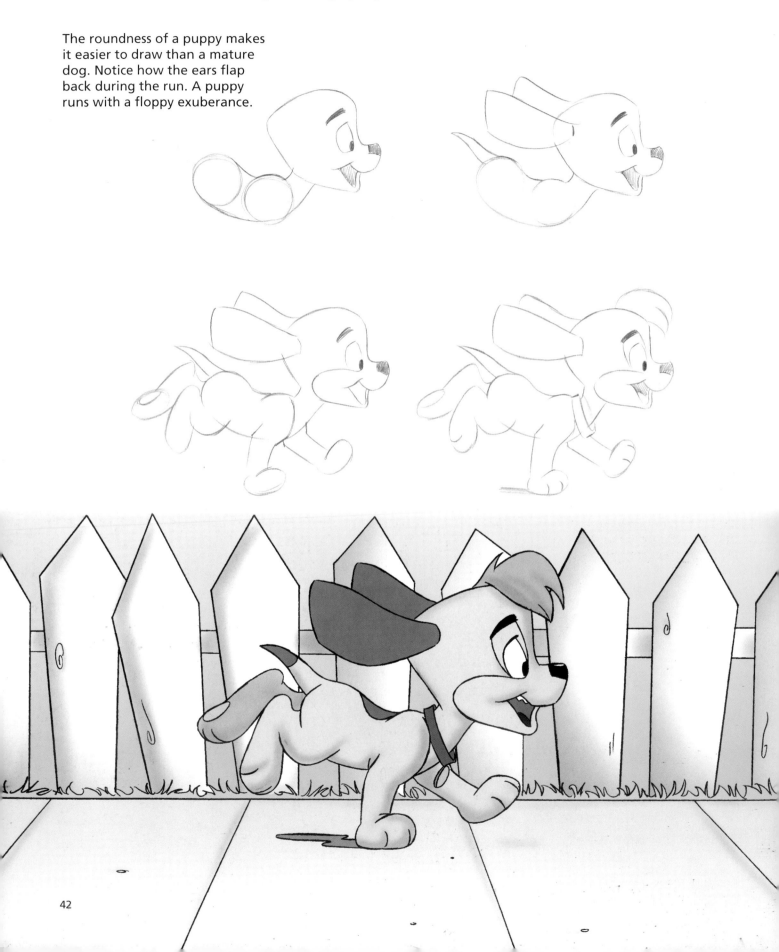

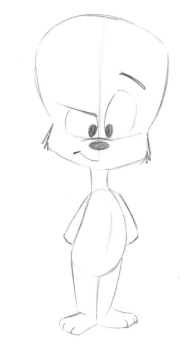
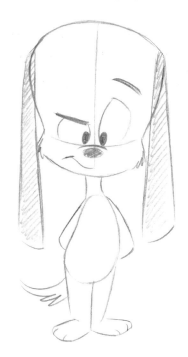

Keeping the basic puppy structure, you can alter the specific features, such as the ears, hairstyle, eyes, and so on, to create an unlimited number of characters.

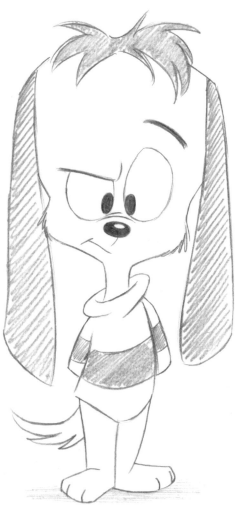

THE MISCHIEVOUS PUP
The standing puppy body is based on a pear-shape torso.

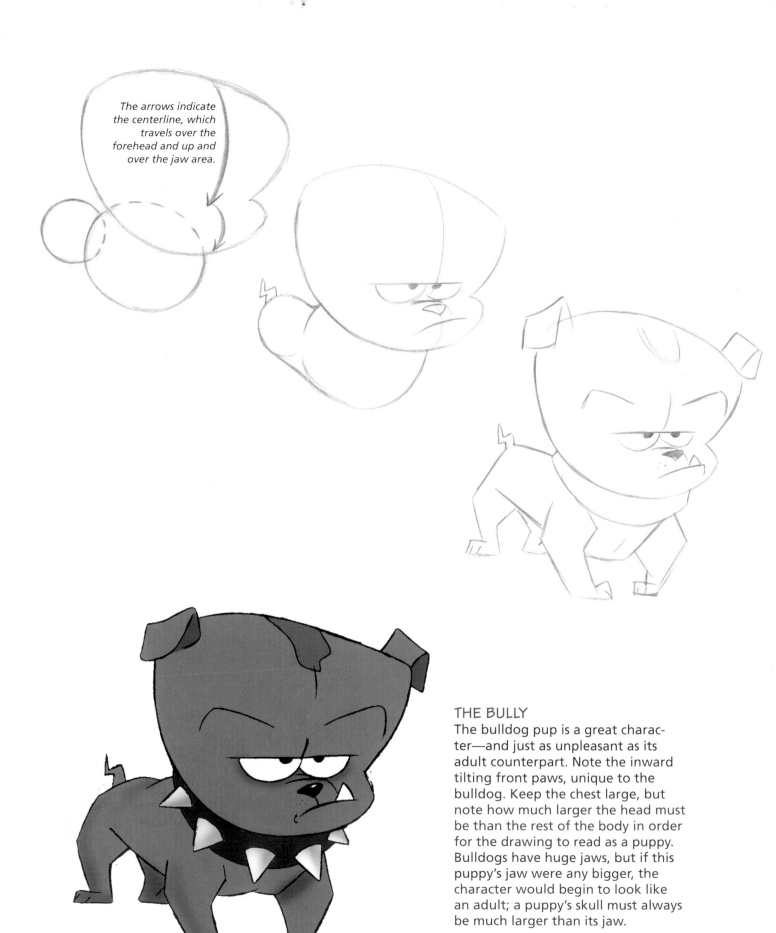

The arrows indicate the centerline, which travels over the forehead and up and over the jaw area.

THE BULLY

The bulldog pup is a great character—and just as unpleasant as its adult counterpart. Note the inward tilting front paws, unique to the bulldog. Keep the chest large, but note how much larger the head must be than the rest of the body in order for the drawing to read as a puppy. Bulldogs have huge jaws, but if this puppy's jaw were any bigger, the character would begin to look like an adult; a puppy's skull must always be much larger than its jaw.

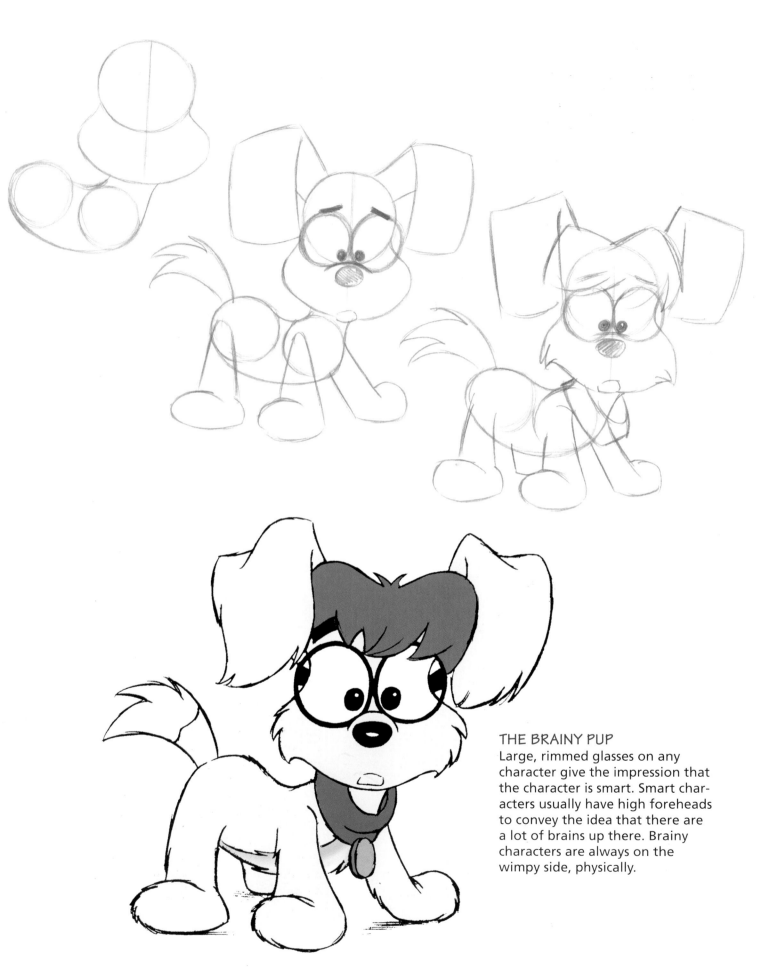

THE BRAINY PUP
Large, rimmed glasses on any character give the impression that the character is smart. Smart characters usually have high foreheads to convey the idea that there are a lot of brains up there. Brainy characters are always on the wimpy side, physically.

Drawing Baby Dogs

Babies are great characters in cartoons, and dog babies are no exception. They are often incredibly loud—sometimes bratty—crybabies who dominate their parents' every waking moments.

Dog babies are drawn differently from puppies; most noticeably, they have short ears, whereas pups have long ears. The body is very small in comparison to the head. Baby dogs are usually drawn fully clothed (always in diapers) and with accessories, bottles, ribbons, rattles, and stuff.

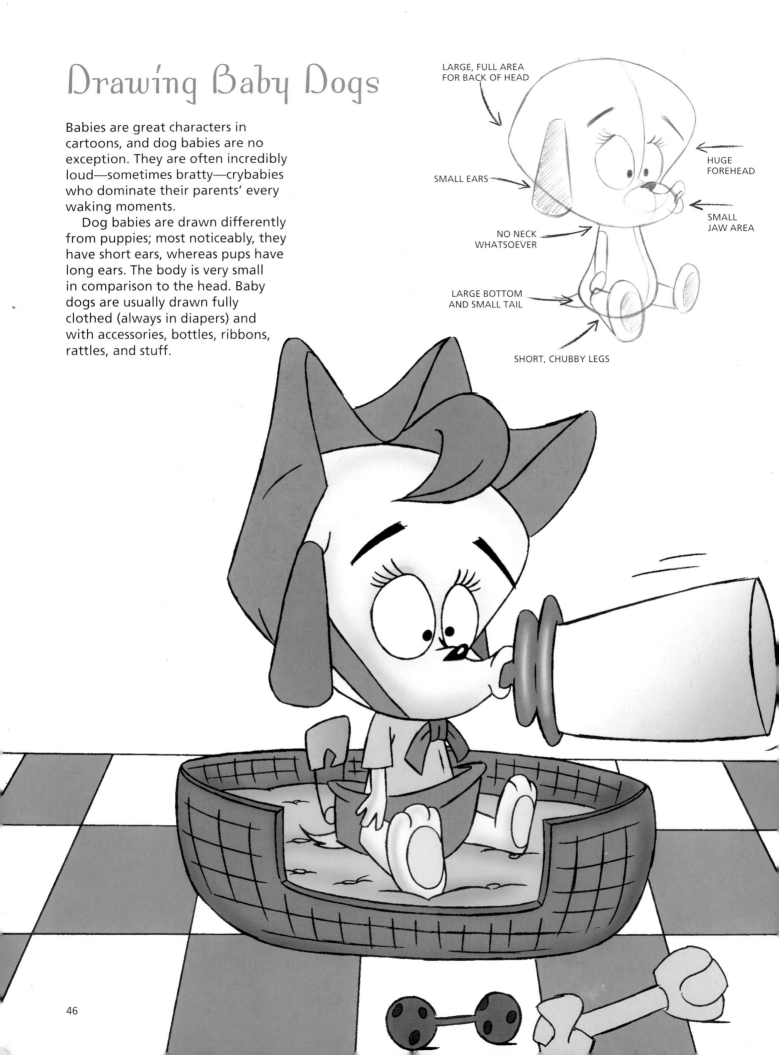

LARGE, FULL AREA FOR BACK OF HEAD

HUGE FOREHEAD

SMALL EARS

SMALL JAW AREA

NO NECK WHATSOEVER

LARGE BOTTOM AND SMALL TAIL

SHORT, CHUBBY LEGS

Many popular comic strip characters have been mutts, whether puppies or adult dogs. There are no rules when drawing a mutt. You can create something very unusual, or just a scruffy, average dog. When people think of mutts, they usually think of medium- to small-size dogs. Mutts are also thought of as being playful animals, the "Artful Dodgers" of the animal world; they roam alleyways, "window shop" at garbage cans, and flirt whenever possible.

You can go very cartoony in your drawing style with mutts. A large ring around one eye is a typical marking for a cartoon mutt. The blackened ears and blackened tip of the tail add variety to an otherwise totally white dog. Markings are just as important for mutts as they are for pure-breds. But mutts' markings are totally your own invention. They serve to add character. Any dog or puppy that isn't an identifiable breed is a mutt.

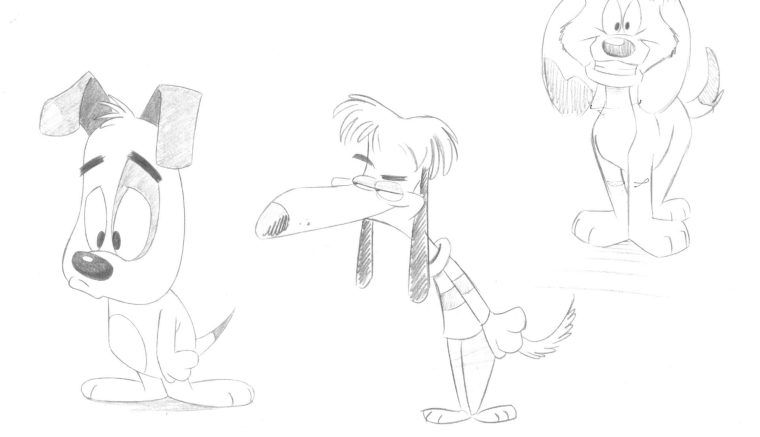

WOLVES

Wolves have been popular for centuries in children's tales, and so it is not surprising that they have firmly established themselves in animated films. They seem to hold a special fascination for humans, who singled them out for domestication over 10,000 years ago. All dogs—from the largest to the smallest—evolved from wolves.

I love to draw wolves, because they make incredibly versatile characters. They can be the most sinister of animals, wacky cartoon types, or droll sophisticates. Wolves generally play the heavy in their cartoon roles.

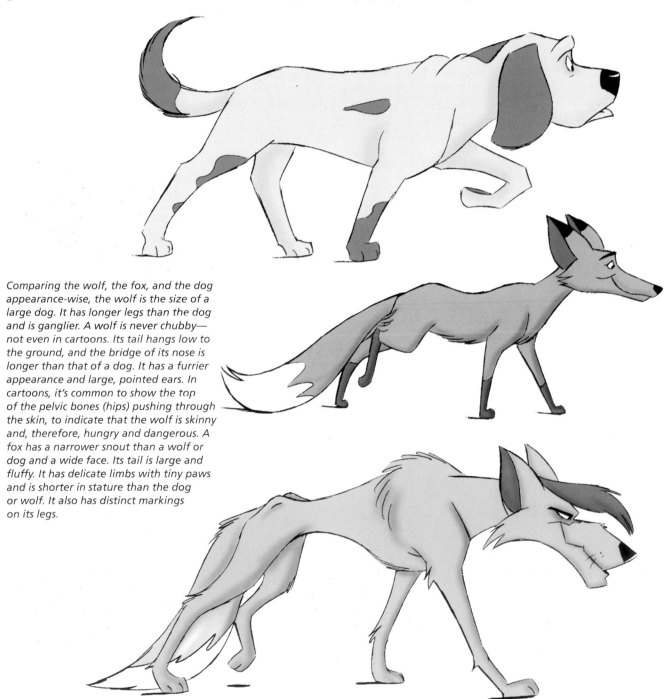

Comparing the wolf, the fox, and the dog appearance-wise, the wolf is the size of a large dog. It has longer legs than the dog and is ganglier. A wolf is never chubby—not even in cartoons. Its tail hangs low to the ground, and the bridge of its nose is longer than that of a dog. It has a furrier appearance and large, pointed ears. In cartoons, it's common to show the top of the pelvic bones (hips) pushing through the skin, to indicate that the wolf is skinny and, therefore, hungry and dangerous. A fox has a narrower snout than a wolf or dog and a wide face. Its tail is large and fluffy. It has delicate limbs with tiny paws and is shorter in stature than the dog or wolf. It also has distinct markings on its legs.

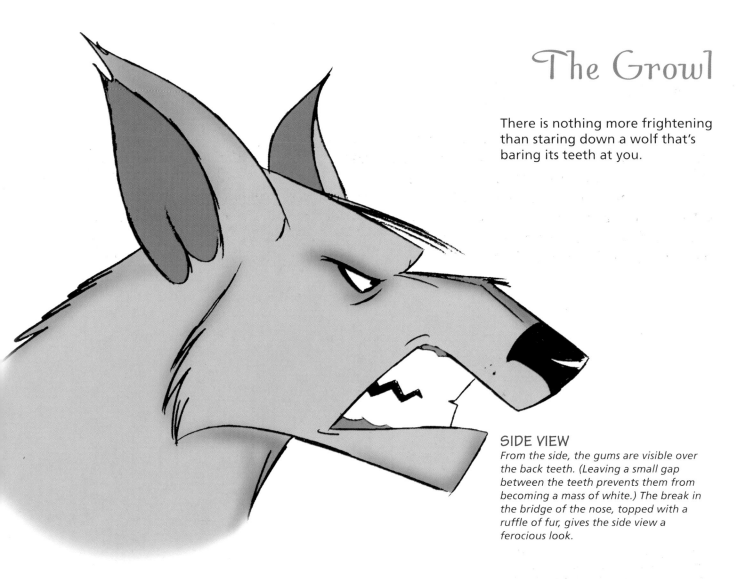

The Growl

There is nothing more frightening than staring down a wolf that's baring its teeth at you.

SIDE VIEW

From the side, the gums are visible over the back teeth. (Leaving a small gap between the teeth prevents them from becoming a mass of white.) The break in the bridge of the nose, topped with a ruffle of fur, gives the side view a ferocious look.

FRONT VIEW

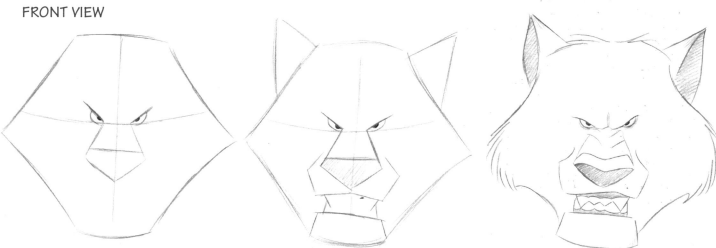

Start with the basic shape of the wolf's head. Draw guidelines, and place the bridge of the nose where the guidelines intersect, the same as for drawing a dog. Note how the eyebrows are really extensions of the lines that form the bridge of the nose. Notice also that the eyes here are closer together than they would be on a dog.

Add the ears, which are almost perfect triangles. The muzzle is the same shape as that of a dog. However, leave a good amount of space for the teeth. Also, the chin becomes wider as it juts out.

Add the top and bottom sets of teeth, which interlock like the interlaced fingers of two hands. Also draw the all-important wrinkles on the bridge of the nose, and ruffle up the fur a little bit. Reveal the gum line, and add some dark circles under the eyes.

The Wolf in Winter

Wolves can well withstand the bitter cold of the wilderness. Vast snow-covered valleys make for great scenes because of two ever-present threats: cold and lack of food.

 Observe how slowly this wolf seems to be moving through the snow. You really *feel* the animal trudging with great effort. How do you achieve this feeling in your drawings? Naturally, the background is important, as are the swirls of wind and the fact that the wolf is ankle-deep in snow. However, the *posture* is even more important. The head hangs low and the eyes are shut tight against the merciless, whipping gusts. All over the body, the fur is blowing in the *same* direction as the wind, in a severe, horizontal angle. In addition, all the wolf's steps are long, to make up for the fact that the pace is so slow. Lastly, the tail is also blown back by the wind.

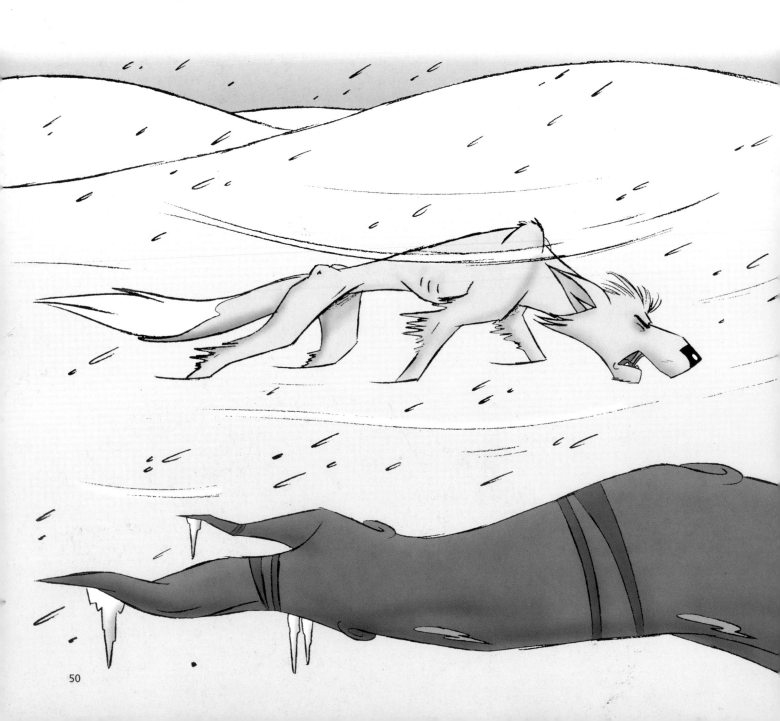

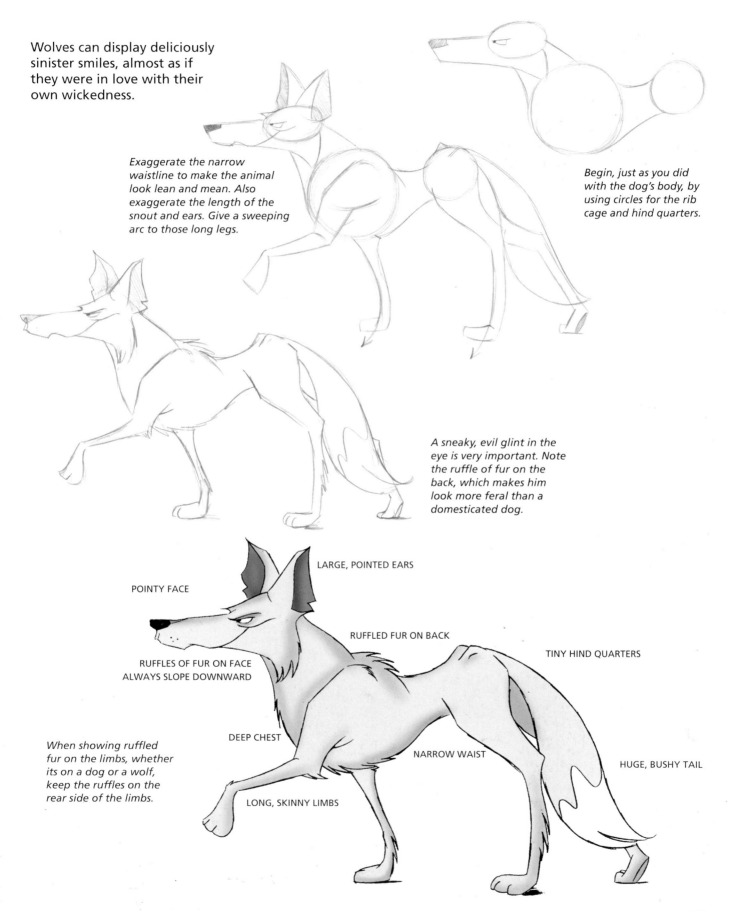

Wolves can display deliciously sinister smiles, almost as if they were in love with their own wickedness.

Exaggerate the narrow waistline to make the animal look lean and mean. Also exaggerate the length of the snout and ears. Give a sweeping arc to those long legs.

Begin, just as you did with the dog's body, by using circles for the rib cage and hind quarters.

A sneaky, evil glint in the eye is very important. Note the ruffle of fur on the back, which makes him look more feral than a domesticated dog.

When showing ruffled fur on the limbs, whether its on a dog or a wolf, keep the ruffles on the rear side of the limbs.

POINTY FACE

LARGE, POINTED EARS

RUFFLED FUR ON BACK

TINY HIND QUARTERS

RUFFLES OF FUR ON FACE
ALWAYS SLOPE DOWNWARD

DEEP CHEST

NARROW WAIST

HUGE, BUSHY TAIL

LONG, SKINNY LIMBS

The Mangy Wolf

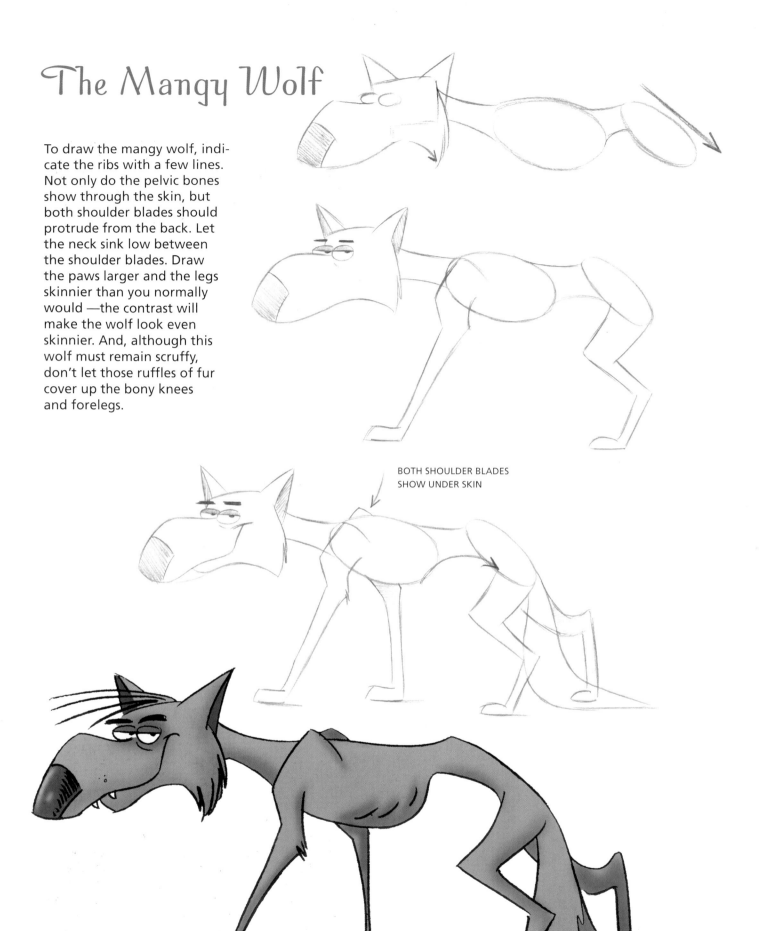

To draw the mangy wolf, indicate the ribs with a few lines. Not only do the pelvic bones show through the skin, but both shoulder blades should protrude from the back. Let the neck sink low between the shoulder blades. Draw the paws larger and the legs skinnier than you normally would —the contrast will make the wolf look even skinnier. And, although this wolf must remain scruffy, don't let those ruffles of fur cover up the bony knees and forelegs.

BOTH SHOULDER BLADES
SHOW UNDER SKIN

The Standing Wolf

Not all wolves are threatening. Some are bumbling characters. A standing wolf is a good example of this; it has human posture and hips that are wider than the chest. Any cartoon character whose hips are wider than the chest is, by definition, *not* intimidating.

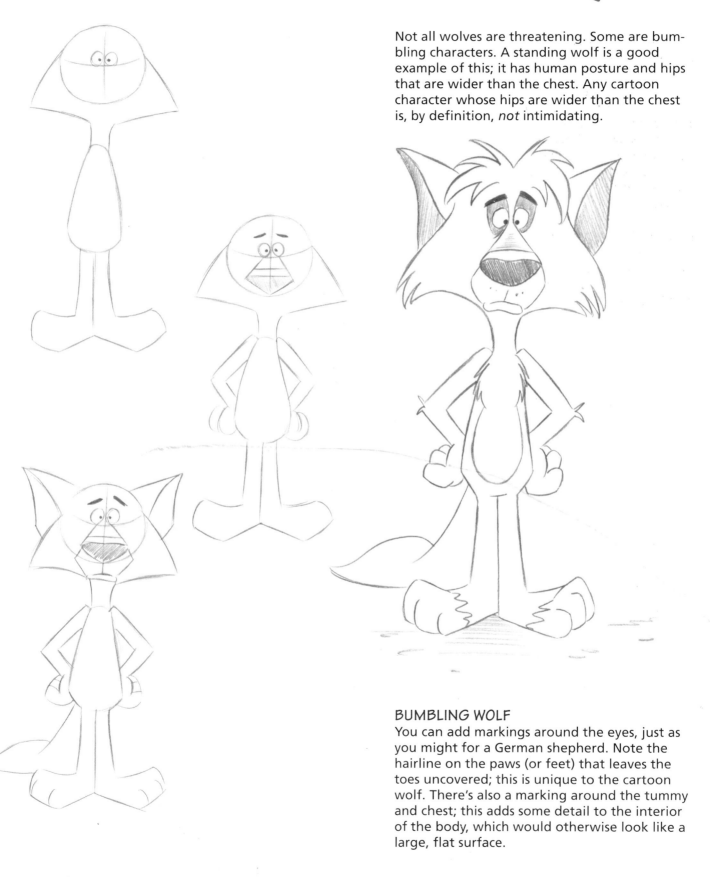

BUMBLING WOLF

You can add markings around the eyes, just as you might for a German shepherd. Note the hairline on the paws (or feet) that leaves the toes uncovered; this is unique to the cartoon wolf. There's also a marking around the tummy and chest; this adds some detail to the interior of the body, which would otherwise look like a large, flat surface.

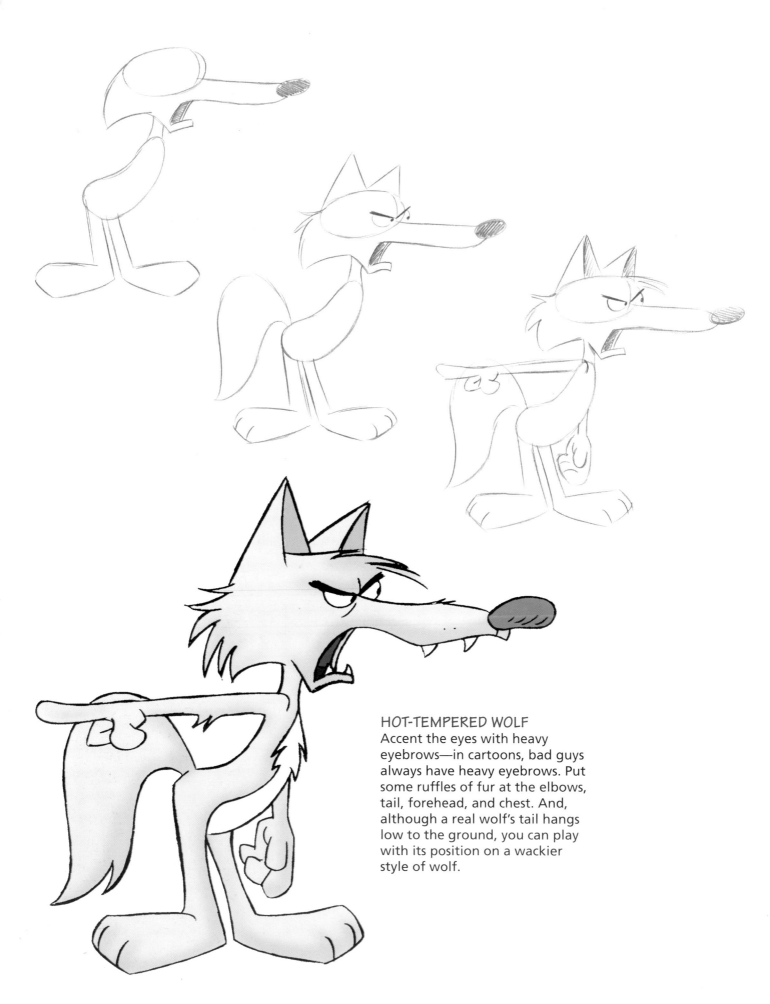

HOT-TEMPERED WOLF
Accent the eyes with heavy eyebrows—in cartoons, bad guys always have heavy eyebrows. Put some ruffles of fur at the elbows, tail, forehead, and chest. And, although a real wolf's tail hangs low to the ground, you can play with its position on a wackier style of wolf.

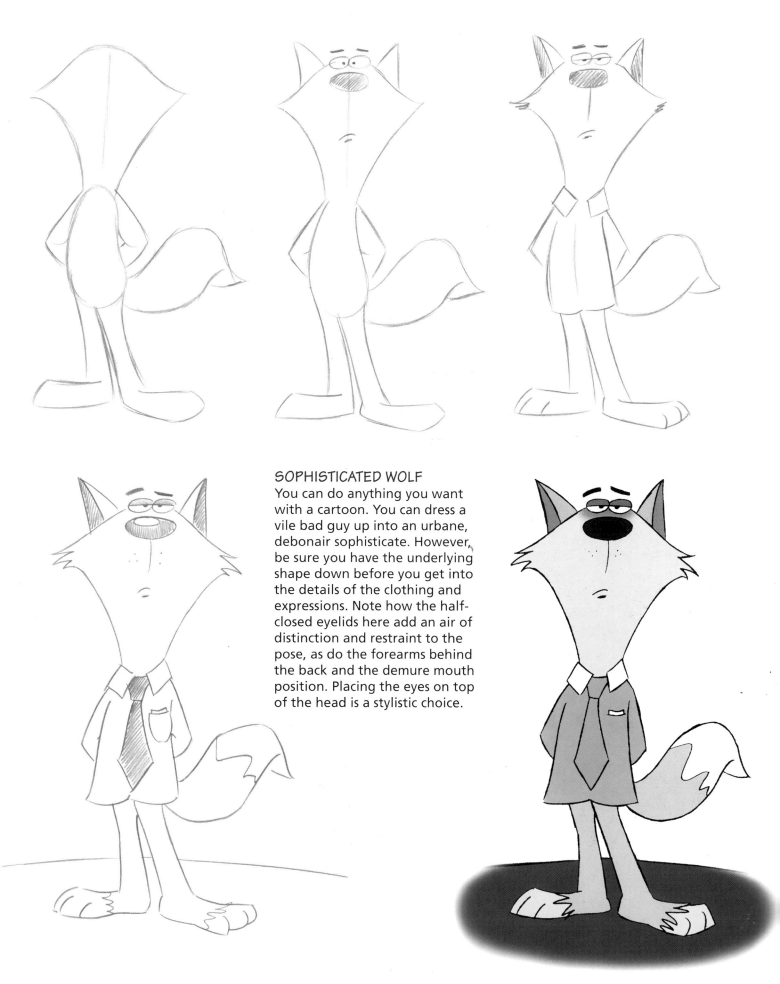

SOPHISTICATED WOLF

You can do anything you want with a cartoon. You can dress a vile bad guy up into an urbane, debonair sophisticate. However, be sure you have the underlying shape down before you get into the details of the clothing and expressions. Note how the half-closed eyelids here add an air of distinction and restraint to the pose, as do the forearms behind the back and the demure mouth position. Placing the eyes on top of the head is a stylistic choice.

AND NOW FOR SOME REALLY WACKY 'TOONS!

After you've got the basics of construction and of creating characters down, there are a few additional techniques and tricks you can use to give your dogs, puppies, and wolves that extra punch. Whether it's adding a hairstyle or costume, or simply tweaking your drawing style, you can always boost your characters' appeal.

Appropriating Human Posture

When should you draw a cartoon dog, puppy, or wolf standing naturally on all fours, and when should you draw it standing upright, like a human being? By drawing an animal character on all fours, you immediately differentiate it from the human world.

However, when a dog appropriates the upright, two-legged posture of a human, it gains an even footing with people and becomes their peer.

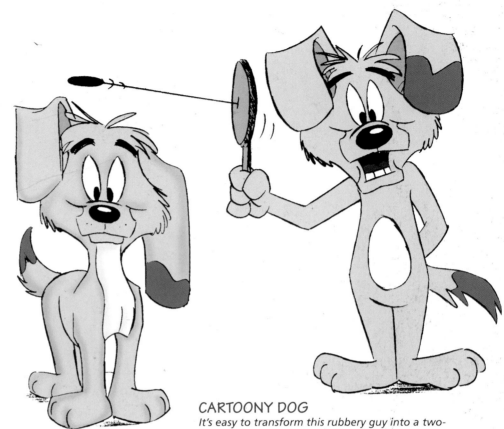

CARTOONY DOG
It's easy to transform this rubbery guy into a two-legged character that stands upright like a person. Even in the four-legged canine stance, the limbs wouldn't show all the joint configurations of a real dog, so it isn't that much of a stretch.

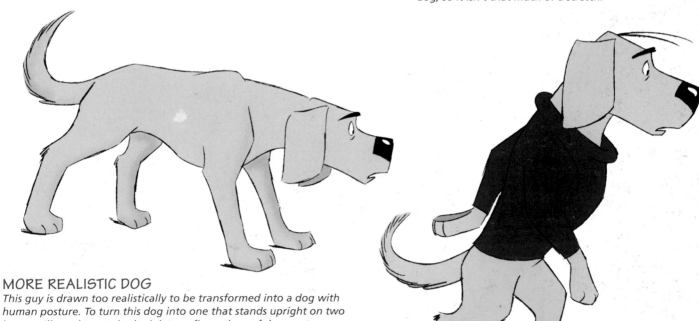

MORE REALISTIC DOG
This guy is drawn too realistically to be transformed into a dog with human posture. To turn this dog into one that stands upright on two legs, you'll need to retain the joint configurations of dog anatomy. As a result, the suggestion of clothing is absolutely necessary to make this dog appear more human. The change to upright posture alone is not enough.

Costumes

Rarely will you see a costume on an animal cartoon character that walks on all fours. However, an animal that acts and walks like a human can easily take a costume. Costumes define the role that a character plays. The personality may be determined by physical size, attitude, and expression, but the costume tells us what the character *does*.

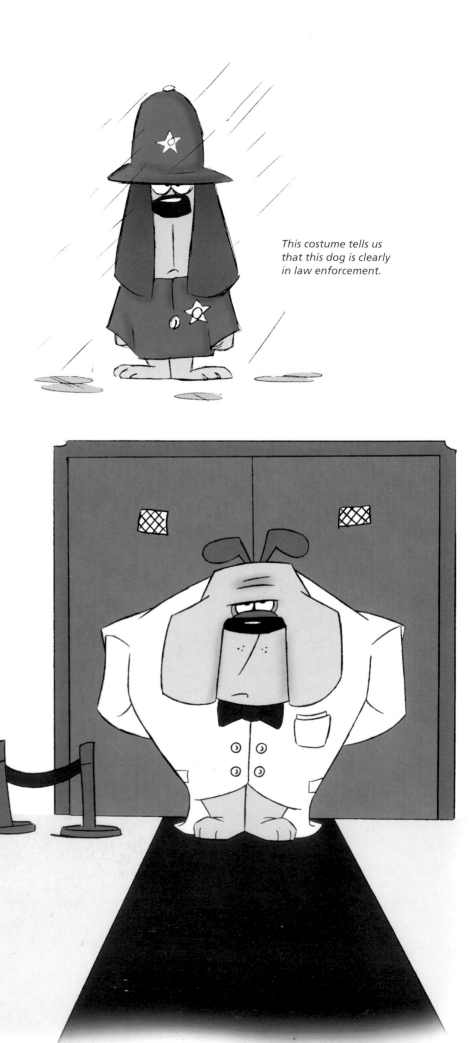

This costume tells us that this dog is clearly in law enforcement.

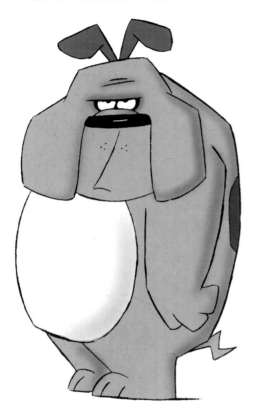

This bulldog above is obviously a tough guy, as are all bulldogs. But what does he do? Is he a dad, a bus driver, or the football coach? There's simply no way to tell without the benefit of a costume. On the other hand, the bulldog at right is clearly a doorman who'll have no trouble keeping out undesirables.

Accessories and Partial Costumes

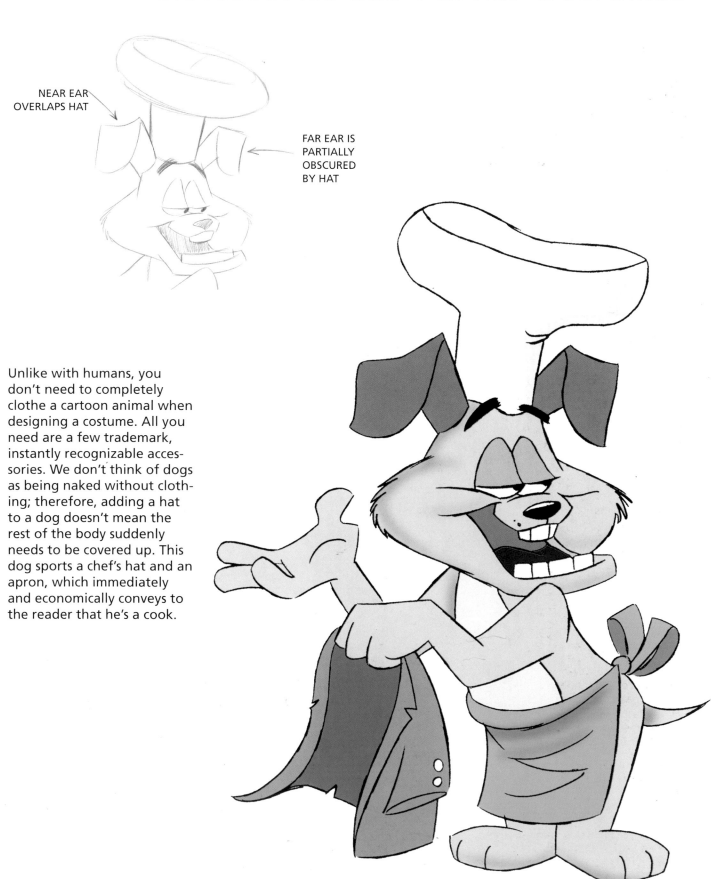

NEAR EAR OVERLAPS HAT

FAR EAR IS PARTIALLY OBSCURED BY HAT

Unlike with humans, you don't need to completely clothe a cartoon animal when designing a costume. All you need are a few trademark, instantly recognizable accessories. We don't think of dogs as being naked without clothing; therefore, adding a hat to a dog doesn't mean the rest of the body suddenly needs to be covered up. This dog sports a chef's hat and an apron, which immediately and economically conveys to the reader that he's a cook.

The Collar & Leash Hair Salon

Hairstyles make fairly human-like cartoon animals seem that much more human. When drawing a substantial haircut, always draw the entire head shape first, and then add the hairstyle. Don't confuse the shape of the haircut with the form of the head. Some hairstyles may cover the ears completely, while others let the ears show through.

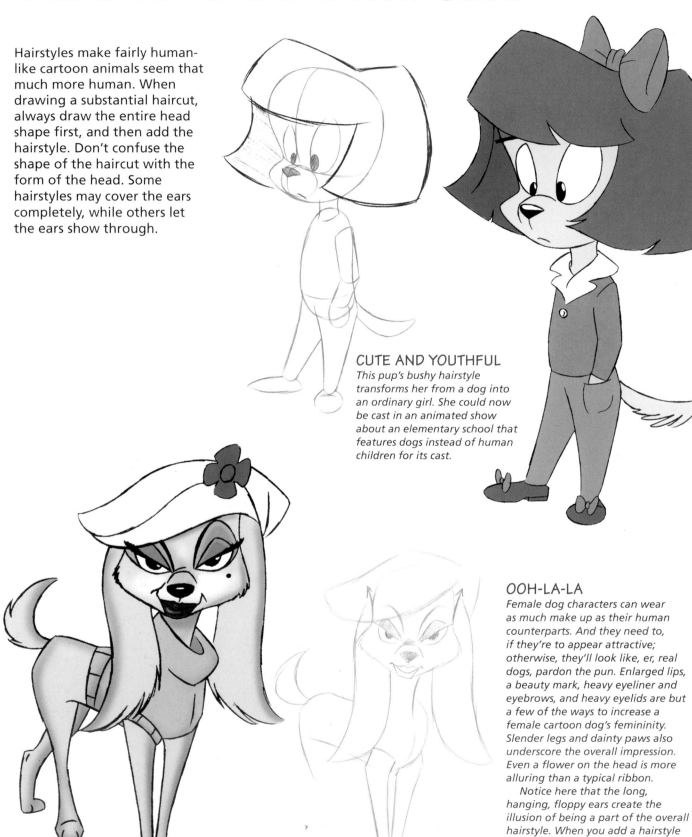

CUTE AND YOUTHFUL
This pup's bushy hairstyle transforms her from a dog into an ordinary girl. She could now be cast in an animated show about an elementary school that features dogs instead of human children for its cast.

OOH-LA-LA
Female dog characters can wear as much make up as their human counterparts. And they need to, if they're to appear attractive; otherwise, they'll look like, er, real dogs, pardon the pun. Enlarged lips, a beauty mark, heavy eyeliner and eyebrows, and heavy eyelids are but a few of the ways to increase a female cartoon dog's femininity. Slender legs and dainty paws also underscore the overall impression. Even a flower on the head is more alluring than a typical ribbon.

Notice here that the long, hanging, floppy ears create the illusion of being a part of the overall hairstyle. When you add a hairstyle to a dog you must work to incorporate the ears into the design, unless the style covers up the ears.

HIP-HOP

CLEAN CUT

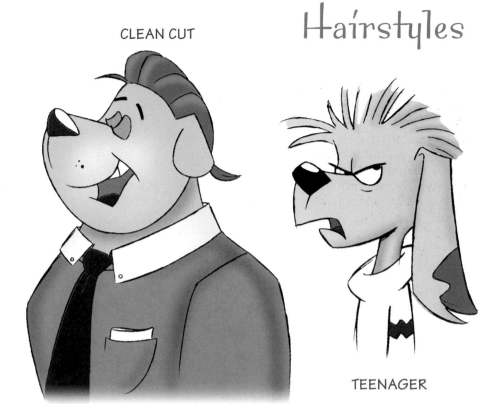

TEENAGER

You can use any hairstyle for a character, provided that the character's face and features (including make-up in the case of females), head construction, ears, and costume together convey a consistent theme.

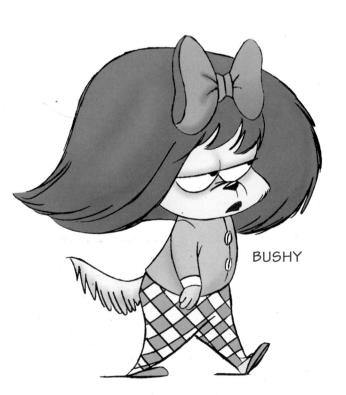

BUSHY

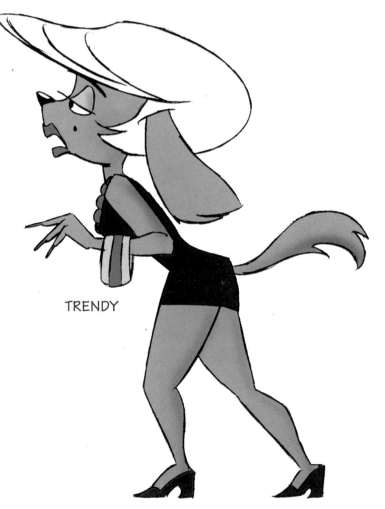

TRENDY

Drawing and Redrawing

Redrawing is a part of the drawing process. Try to take an objective look at your work in progress. Don't fall in love with it while you're still working on it. Make adjustments. Experiment. Chip away at what doesn't work and chuck those things. Here are some of the stages that this cowboy went through on his way to becoming a finished character, and some of the thoughts that went into refining it.

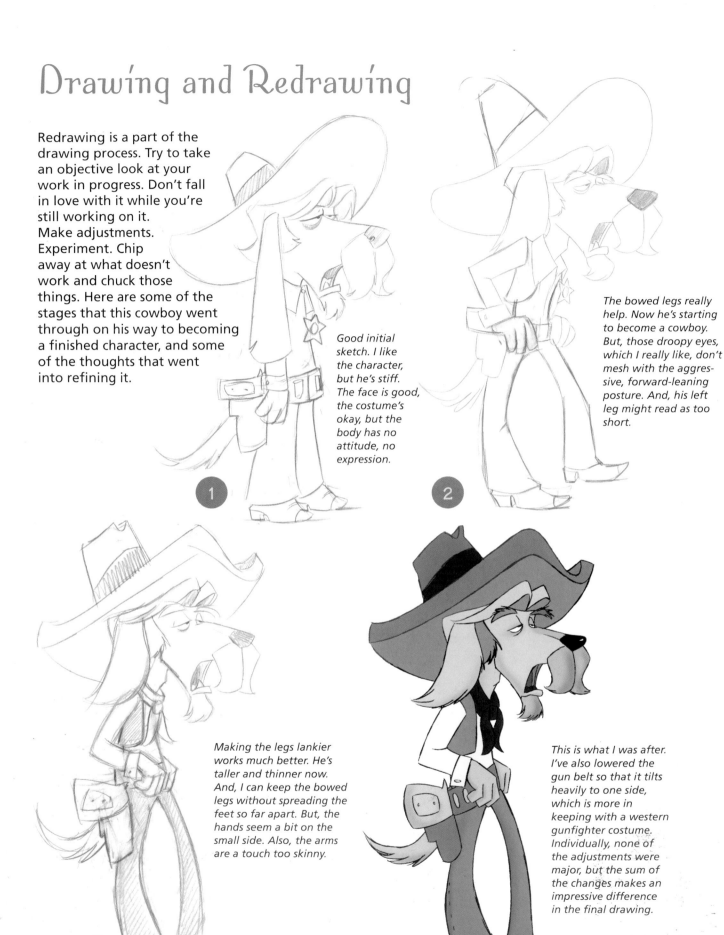

Good initial sketch. I like the character, but he's stiff. The face is good, the costume's okay, but the body has no attitude, no expression.

1

The bowed legs really help. Now he's starting to become a cowboy. But, those droopy eyes, which I really like, don't mesh with the aggressive, forward-leaning posture. And, his left leg might read as too short.

2

Making the legs lankier works much better. He's taller and thinner now. And, I can keep the bowed legs without spreading the feet so far apart. But, the hands seem a bit on the small side. Also, the arms are a touch too skinny.

3

This is what I was after. I've also lowered the gun belt so that it tilts heavily to one side, which is more in keeping with a western gunfighter costume. Individually, none of the adjustments were major, but the sum of the changes makes an impressive difference in the final drawing.

4

Boys and Girls Together

Beyond using bows and baseball caps to indicate gender, you should alter your drawing *style* when drawing a male or a female dog. Typically, the "boys" are drawn more cartoony, big-nosed, and round, whereas the "girls" appear more realistic and refined. Ain't it the truth? The exception to this is in cartoons about very young dogs—ages one to seven. In those cases, both the girl dogs and the boy dogs are represented in a cartoony style. However, as soon as they're old enough to be attracted to the opposite sex, the females are drawn to be more attractive and the males are drawn to still appear gawky.

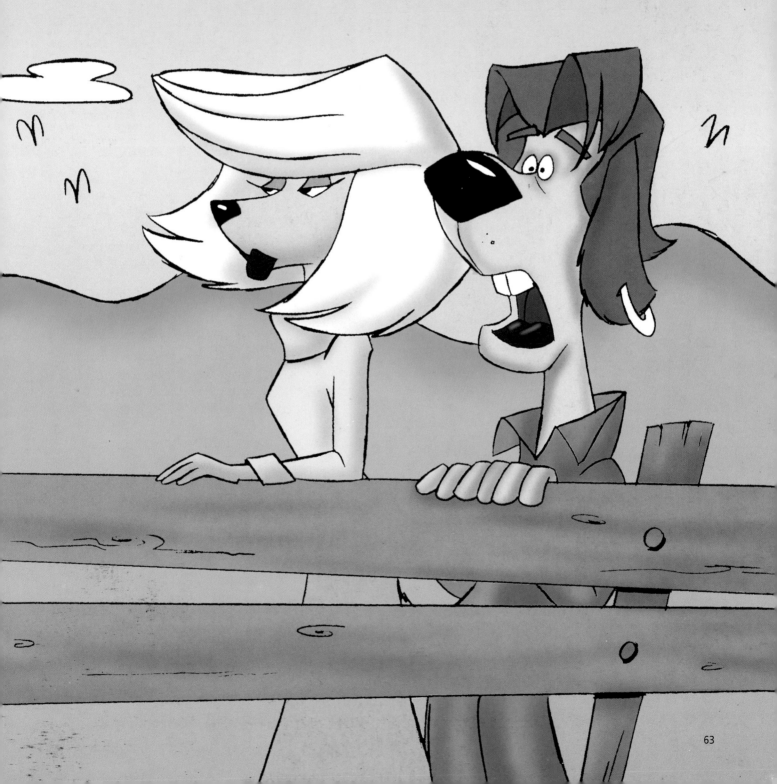

INDEX